IMAGES
of America

BROKEN ARROW
CITY OF ROSES
AND PURE WATER

IMAGES
of America

BROKEN ARROW
CITY OF ROSES
AND PURE WATER

Donald A. Wise

ARCADIA

Published by Arcadia Publishing,
an imprint of Tempus Publishing, Inc.
3047 N. Lincoln Ave., Suite 410
Chicago, IL 60657

Printed in Great Britain.

Library of Congress Catalog Card Number: 2002111044

For all general information contact Arcadia Publishing at:
Telephone 843-853-2070
Fax 843-853-0044
E-Mail sales@arcadiapublishing.com

For customer service and orders:
Toll-Free 1-888-313-2665

Visit us on the internet at http://www.arcadiapublishing.com

CONTENTS

ACKNOWLEDGMENTS

The purpose of this book is to record a brief history of the City of Broken Arrow, Oklahoma, which was also known as the "City of Roses and Sparkling Spring Water."

The author has lived in the Broken Arrow area some twenty years, and before that some ten years in another part of the state of Oklahoma. He has also lived in several large cities such as Tokyo, Japan; St. Louis, Missouri; and Washington, D.C. This diversified background has made the author more aware of the many-faceted cultural backgrounds of peoples and their place in this fascinating world.

Much of the material, such as the vintage images, has come from the Broken Arrow Historical Society files. Some images were found in the Western History Collections at the University of Oklahoma. Other material came from the First United Methodist Church Archives and from private collections of individuals in the local area. Our local libraries have some good texts on the history of Oklahoma. The microfilm copies of the early local newspapers are great sources of information, along with some of the local oral histories.

Mr. O.T. "Andy" Anderson did the photographing of some images in the Broken Arrow Historical Society files. We do appreciate his expertise in making these images possible. Other photographs were taken by the author to compare the vintage images with the present structures in the City of Broken Arrow.

This year the City of Broken Arrow, Oklahoma, is celebrating its birthday of 100 years since its founding in 1902. The Broken Arrow Centennial Committee is attempting to collate all functions during this year-long celebration of the City, starting in October, 2002.

Finally, I want to thank my wife, June, for her support and encouragement while doing this project.

<div align="right">

Donald A. Wise
5 July 2002
Broken Arrow, Oklahoma.

</div>

INTRODUCTION

In October, 1831, Lieutenant James L. Dawson and eight men explored the Arkansas Valley from Fort Gibson to the mouth of the Cimarron River. His official report of this expedition gives one of the first specific descriptions of the area around Broken Arrow.

The Henry L. Ellsworth Expedition came through Indian Territory in October, 1832. The official report gave us a further description on events and the lands which they explored. Part of the Ellsworth journey was through the area which later became the City of Broken Arrow, Oklahoma. Washington Irving was in this expedition and his book A *Tour of the Prairies* also gave details about this area.

In 1828 the first party of Creek Indians from Georgia settled in the Three Forks Area where the Arkansas, Verdigris and Grand Rivers converged. Those Creek Indians who did not want to leave their ancestral lands in Georgia and Alabama were forced to either walk or ride to the new lands in Indian Territory. There were many who died along the way—the sick, the young, and the old people. This trek is known to the Creek Indians as the Trail of Tears. It is estimated that perhaps one-half of the Creek Indians who were removed during the period 1830–1836 died along the way. The Choctaw suffered a similar fate the following year, and in 1838, in the most infamous removal, the Cherokee suffered in even greater numbers.

The Civil War resulted in the Indian nations in Indian Territory either joining the Confederate Army or becoming a member of the Union Army. About 2,220 Cherokees served in the Union Army and about 1,400 with Confederate forces. The Creek tribe supplied 1,675 men for the Union Army and 1,575 for the Confederate. Arguably no portion of the United States endured more hardships from the Civil War than the people in Indian Territory. The flight of refugees, first Union families to the north and then Confederate families to the south, was a regular feature of the Indian campaign. Livestock losses were heavy throughout the Indian Territory. The neglect of the land, burning of homes and destruction of public buildings created a general atmosphere of ruin and desolation. Public education was in a low state throughout Indian Territory; schools were suspended during the war and many of these buildings were destroyed.

All tribes were required to make concessions. Slavery was abolished and all Freedmen, which were formerly slaves of the Creek or Cherokee Nations, were given tribal rights. A right of way was granted by each nation for one railroad running north and south and one running east and

west. Most of the Indian lands in the western part of the Five Civilized Tribes—Cherokee, Chickasaw, Choctaw, Creek, and Seminole—were ceded to the United States and used to settle the Plains Indians.

After the end of the War in 1865, the cattle industry was extensive in this area. George Perryman, a Muscogee (Creek) Indian, claimed a cattle pasture from 21st Street on the north to 71st Street on the south, between the Arkansas River and the Verdigris River. This area would include the future site of the City of Broken Arrow. Only Creek citizens could enclose and utilize such large areas of tribal lands. Perryman had one of the largest ranches in the local area and would lease some of his lands to the Texas ranchers. James M. Daugherty of Texas leased the area north of Broken Arrow and east to the Verdigris River from Perryman. Jay Forsythe leased the area west and northwest of Broken Arrow. A third large pasture is located near what was the southwest corner of the Daugherty pasture where thousands of cattle grazed during the spring before being driven to market.

A townsite announcement appeared in the *Tulsa Democrat* newspaper on October 17, 1902. It stated that the town of Broken Arrow is now open to the public and those interested should contact the National Realty Company in Tulsa or Broken Arrow; or the Arkansas Valley Townsite Company in Muskogee. A small wooden building was used by the National Realty Company in Broken Arrow in 1902 to sell lots in the Arkansas Valley Townsite Company.

The Missouri, Kansas and Oklahoma Railroad did the survey and constructed a branch line from Wybark (Muskogee) to Osage Junction (west of Tulsa). The chief advantage in building under a separate charter lay in the simplicity of financing the work. Immediately upon completion, the Missouri, Kansas and Texas (KATY) Railroad took over the possession and operation of the Missouri, Kansas and Oklahoma (MK & O) Railroad.

The Broken Arrow Townsite was surveyed and platted by Samuel A. Cobb, a civil engineer with the Townsite Department of the Indian Office (now BIA) in Muskogee. The townsite plat is dated October 16, 1902, and consisted of 220 acres of land laid out in a north-south and east-west direction on either side of the proposed KATY Railroad track, which would later intersect the townsite at a 45 degree angle.

In 1865 slavery was abolished and each Freedmen was given citizenship in the Creek Nation and, under the Dawes Commission, were allotted 160 acres of land. A majority of the land in the Broken Arrow Townsite was purchased from two Freedmen of the Creek Nation. One of these Freedmen was Harry Alexandria Sells (F-2616) who sold 80 acres of his allotment to the Arkansas Valley Townsite Company. His wife, Jane (McIntosh) Sells (F-2517), sold 40 acres of her allotment to the Arkansas Valley Townsite Company. They also had land near Muskogee where their descendants live today.

The original KATY Railroad Depot was 24 by 50 feet in size. It was constructed of wood with a red tin roof, set upon wooden pilings. The Missouri, Kansas and Texas (KATY) Railroad, built during May of 1903, was the main reason for the location of the town of Broken Arrow. The KATY Railroad track construction reached Broken Arrow on April 13, 1903.

Other buildings along Main Street were soon completed and open for business. One of the early exports from this area were the logs from huge walnut trees in the river bottoms. These logs were in demand in Europe to use in making furniture.

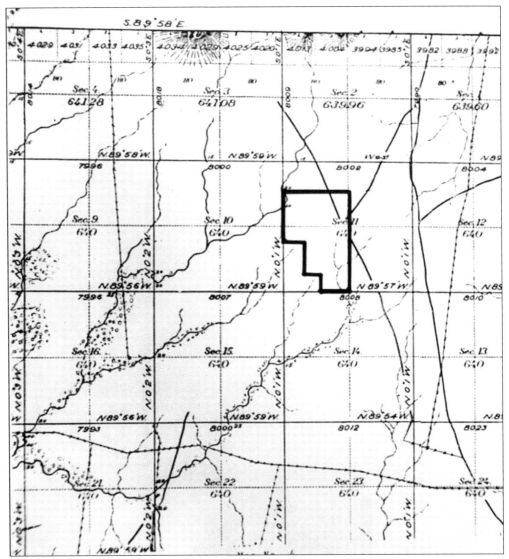

This 1896 General Land Office map shows the drainage patterns and fenced areas to contain the herds of cattle. The outline of the Broken Arrow Townsite of 1902 is superimposed.

9

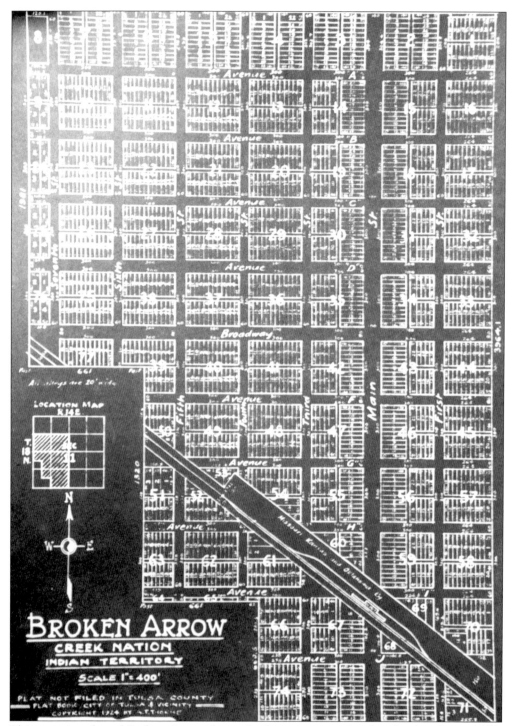

This townsite plan of Broken Arrow shows the lots, streets, and railroad right-of-way, 1902. Main Street is portrayed in the north-south direction on this plat ending at the KATY Railroad Depot. Later, as the town developed, the KATY Railroad Depot was moved several hundred feet west to permit Main Street traffic to cross the tracks and to continue south.

10

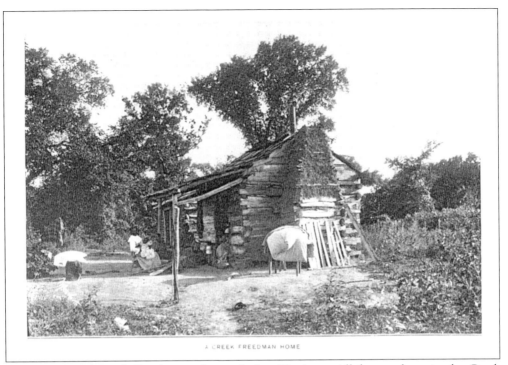

A CREEK FREEDMAN HOME

This is a typical Creek Freedman cabin in Indian Territory. All former slaves in the Creek Nation were made citizens and entitled to 160 acres of land for each person.

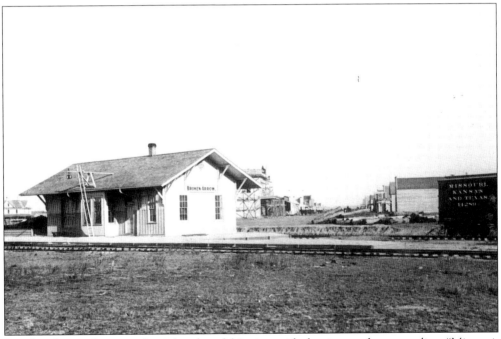

A railroad car is shown in the right edge of this view with the sign on the car reading: "Missouri, Kansas and Texas Railroad." The depot is on the left. Note the hickory logs on the railroad siding on the right.

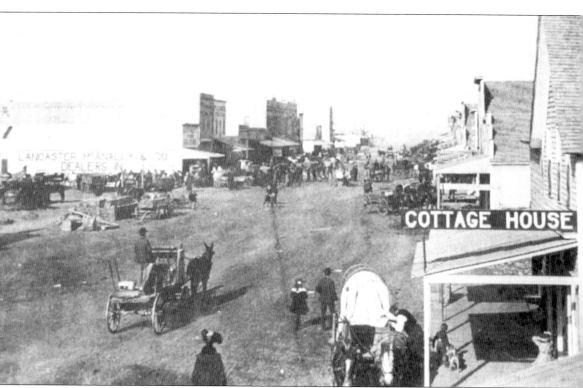

This view is looking north on Main Street, 1903 The Kentucky Colonel Hotel was being constructed just north of the KATY Railroad Depot.

One

BROKEN ARROW

The origin of the modern City of Broken Arrow was the result of the Missouri, Kansas, and Texas (KATY) Railroad being constructed from Muskogee to Tulsa. It reached Broken Arrow on April 13, 1903. The Broken Arrow townsite was laid out on both sides of the KATY Railroad track by the Arkansas Valley Townsite Company. This business firm was incorporated in Indian Territory in 1902 and was interested in developing townsites. They had the townsite rights to develop Porter, Coweta, and Broken Arrow. William S. Fears, secretary of the Arkansas Valley Townsite Company, inspected the proposed route of the KATY Railroad and selected a site near two high mounds and about 15 miles southeast of Tulsa. Fears decided the name of Broken Arrow would be appropriate for the new townsite since the Broken Arrow Creek Indians had settled about six miles south along the north side of the Arkansas River.

The original survey and plat of the Broken Arrow townsite was made by Samuel A. Cobb, a civil engineer with the Townsite Department of the Indian Office in Muskogee. It included a 120-acre tract of land which had been allotted by the Creek Nation to Stephen Franklin (F-3155) and 80 acres of land allotted to Harry Sells (F-2616), both Freedmen. Forty acres of land on the south edge of the Broken Arrow townsite were purchased later by the Arkansas Valley Townsite Company from Billy Atkins (C-826), a Muscogee (Creek) Indian, who had a 160-acre allotment in this area.

When the townsite of Broken Arrow was surveyed and platted in 1902, warranty deeds could not be issued to the property since it was restricted land allotted by the Creek Nation. This was changed by the Indian Appropriation Act of March 3, 1903. This gave authority to the Arkansas Valley Townsite Company to purchase the lands from Franklin, Sells, and Atkins. The Townsite Company was able to issue warranty deeds for the lots in the Broken Arrow townsite.

The Petition for the Incorporation of the town of Broken Arrow was filed at the United States Courthouse in Muskogee, Indian Territory, on March 30, 1903, and was approved by the court on May 4, 1903, in Broken Arrow. The elected members of the Broken Arrow Town Council were duly qualified by attorney Z.I.G. Holt at their first meeting held on July 10, 1903.

Broken Arrow has a City Council/Manager form of government. The City Council, which includes the mayor, is made up of elected officials who serve the city without pay. The City Manager is a paid position and is responsible for the every day running of the city.

The 1904 school census for Broken Arrow found a total population of 1,021. The Federal Government Census for Broken Arrow in 1910 lists a population of 1,383. There was a steady growth of population in Broken Arrow in succeeding years. In 1960, there was a population of 5,982. However, the real growth of Broken Arrow came after the population doubled in 1970 to 11,787. It tripled in 1980, and today the estimated population for Broken Arrow is about 81,000. This would make Broken Arrow the second largest city in eastern Oklahoma and the fifth largest urban area in the State of Oklahoma.

The place name of Broken Arrow actually is derived from an Indian community, *Thlikachka*, or Broken Arrow, in Alabama on a tributary of the Chattahoochie River. When the Muscogee (Creek) Indians from Thlikachka were moved to Indian Territory in 1836, they decided to settle along the Arkansas River in the vicinity of a tributary now known as Broken Arrow Creek. There they established a town square where they held ceremonial and political meetings. The late Walter McHenry, a Muscogee (Creek) Indian, indicated to the author that the site of the old community square was west of Broken Arrow Creek and north of East 121st Street, South (also known as Tucson Street) within the present boundaries of the City of Broken Arrow.

Supporting evidence for the origin of the place name, Broken Arrow, is found in a number of primary and secondary sources in Indian Territory (now Oklahoma), Alabama, and Georgia. These sources are all documented in an article: "Origin of the Place Name of Broken Arrow" which was published in the Chronicles of Oklahoma, Vol. LXIX, No. 1, (Spring, 1991): 92-97.

According to William Alexander Read in his 1937 Indian Place-names in Alabama, the place-name of Broken Arrow was "a creek in Russell County, Alabama. A Lower Creek town called Likachka, which was situated on the Chattahoochie River near this creek. The source of the name is Creek: *li*, 'arrow,' and *kachki*, 'broken,' from the Creek word *Kachkita*, 'to be broken.'" The settlement was evidently founded by Indians who broke reeds to make shafts for their arrows.

Tipis were a common type of housing for the Plains Indians. This was a display at an Indian Smoke Shop in Broken Arrow. The Civilized Tribes usually had a log cabin or house made of sawed timber.

14

In early Broken Arrow, which had been developed upon prairie land, the planting of trees, bushes and flowers were mandated. The rose bush, in particular, was a greatly admired addition to the landscape. Hence, Broken Arrow became known as the "City of Roses."

A common greeting card was embellished with roses. This one had a special welcome using "Greetings From Broken Arrow, Okla."

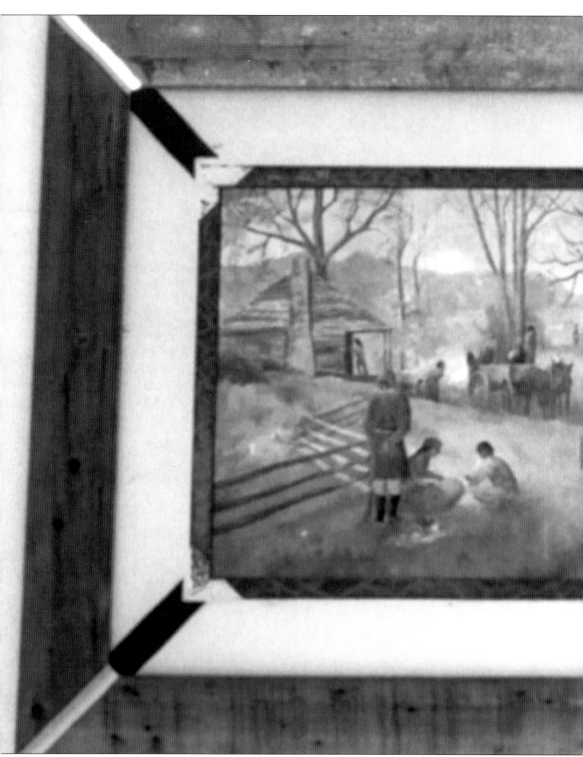

The removal of the Indians from their homelands in Georgia and Alabama was enforced by the U.S. Army. Many young, old, and sick died along the way. This is known as the "Trail of

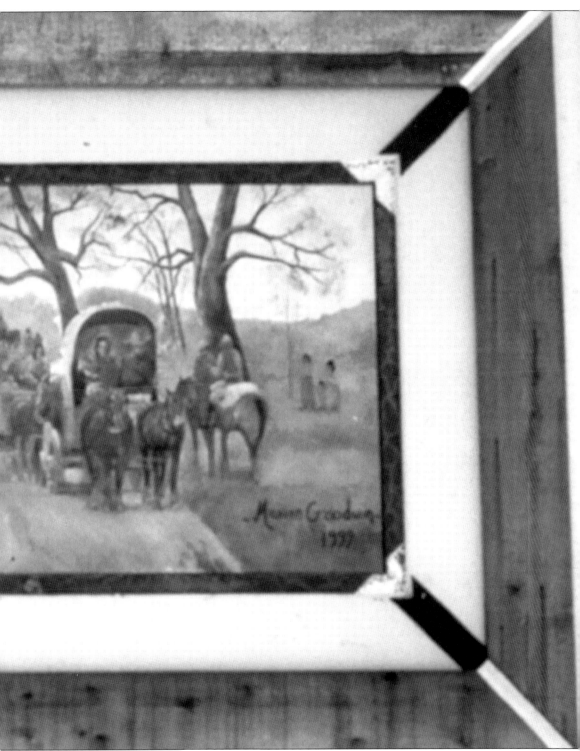

Tears." This mural is on the wall of the Farmers Cooperative in Broken Arrow. It indicates the beginning of the Trail of Tears as portrayed by artist Marian Goodwin.

This country, Indian Territory, was a great pasture for cattle. Land was leased from the Creek Nation and fenced to contain the herds of cattle from Texas. The Indians benefited from this arrangement until the Dawes Commission started giving each member of the Creek Nation 160 acres of land. Land was then sold to the white settlers who developed farms and mining activities.

THE CIVIL WAR 1861-1865

During the Civil War period, 1861–1865, some Indians joined the Confederate Army and others joined the Union Army. Some wanted to remain neutral, but all were effected by the tragedy of war.

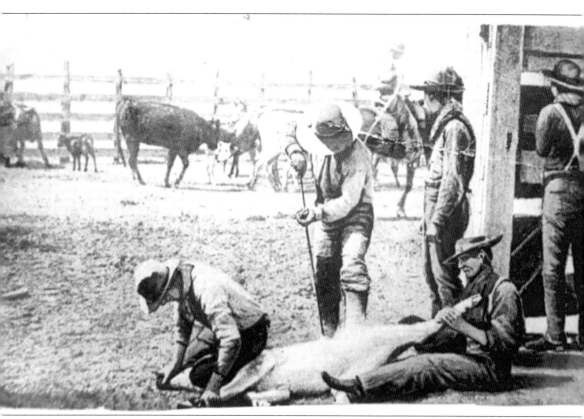

Cattle roundups were necessary to the branding of each animal with a distinctive mark. This enabled the rancher to claim ownership of the cattle.

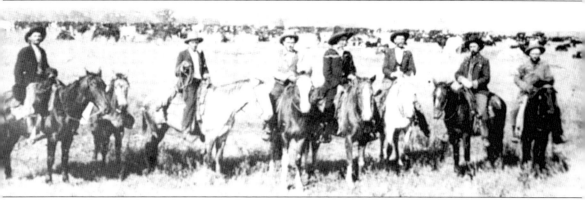

J.M. Daugherty had a ranch in the Broken Arrow area. In 1896 he had 40,000 cattle grazing on his ranch.

Announcement!

The Arkansas Valley
TOWNSITE COMPANY

Announce that the town of BROKEN ARROW, on the M. K. & O. Railroad,

The Railroad town of Elam, Fry and Weer.

IS NOW OPEN TO THE PUBLIC.

IN turning this town over to the public, the Company desires to here state that IT IS NOT its purpose to boom this town and "get from under" as soon as possible, but to manage its growth that by healthful strides it may grow to be a good, substantial town, and to this end has, as far as possible, tried to eliminate that speculative feature which we believe to be detrimental to any town. The country contiguous and tributary to BROKEN ARROW has in the past supported three good inland towns and will certainly not be worse with the advent of the railroad.

THE Agricultural Wealth of the valley between the Arkansas and Verdigris rivers is to well known to be commented upon, and anything we might say in this announcement would be taken by the public with the customary "grain of salt."

TO those seeking a location or investment, and who are not acquainted with the location or character of the country, we would suggest that they would be amply repaid by a close personal inspection.

Broken Arrow is 15 Miles Southeast of Tulsa and has one of the Prettiest Locations along the New Line.

WE would therefore suggest, That All Persons Desiring to Engage in Business at Broken Arrow, come to the office of

THE NATIONAL REALTY COMPANY, in Tulsa & Broken Arrow; or
Arkansas Valley Townsite Company, Muskogee, I. T.

AS EARLY AS POSSIBLE TO SECURE AVAILABLE SITES.

This is the announcement which appeared in the Tulsa newspaper indicating the sale of lots in the Broken Arrow Townsite Company in 1902.

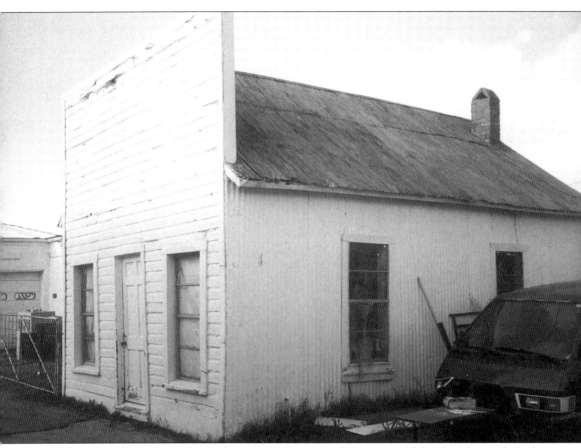

This is the office where the Broken Arrow Townsite lots were sold by the National Realty Company in 1902. In December of 1902, this building was used by the Traders and Planters Bank until its new brick structure was completed in 1903. In 1917 it was used as a shoe repair business by the Harness brothers. This building is now located fronting the east side of the alley south of East Dallas Street and the Municipal Building. It is now used for storage. This small wooden structure is most likely the oldest business office extant in Broken Arrow.

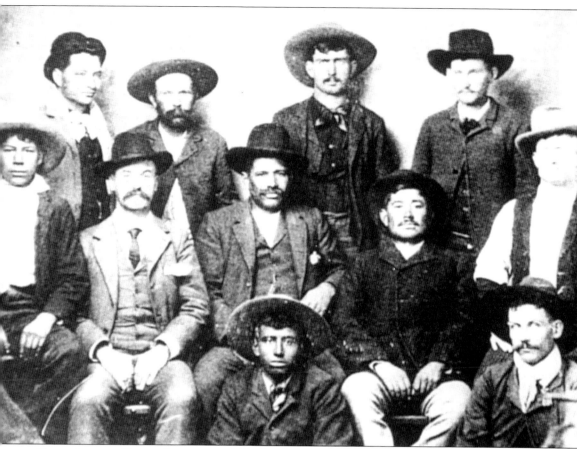

Shown here are George Perryman and His Cowboys, 1891. They are, left to right: (bottom row) Sam Beaver and Jim Grass; (middle row) Spot Childers, J.H. Morrow, George Perryman, Mose Perryman, and Claude Flippen; (top row) Reubin Partridge, Tom Kenny, Nate Goodman, and Dent Ray.

The Dawes Commission gave each Creek citizen 160 acres and prepared maps such as this to show ownership of these lands.

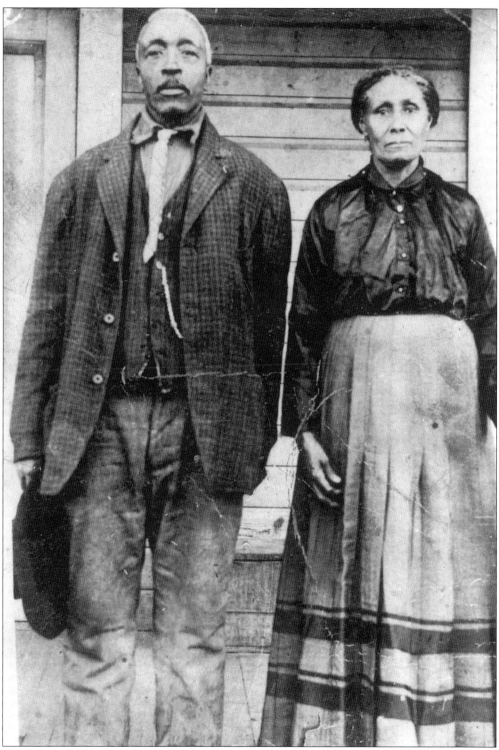

Harry Sells (1855–1930)[F-2616] and Jane Sells (1855–1935)[F-2617] sold their allotments to Broken Arrow Townsite Company in 1904.

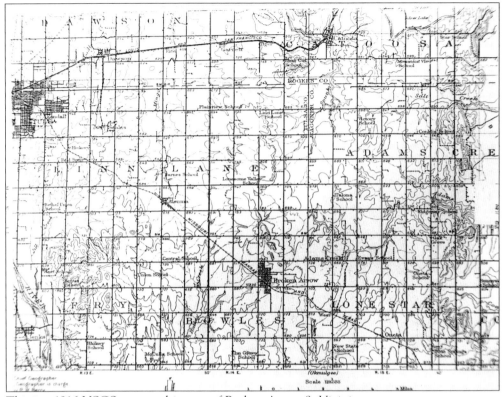

This is a 1916 USGS topographic map of Broken Arrow & Vicinity.

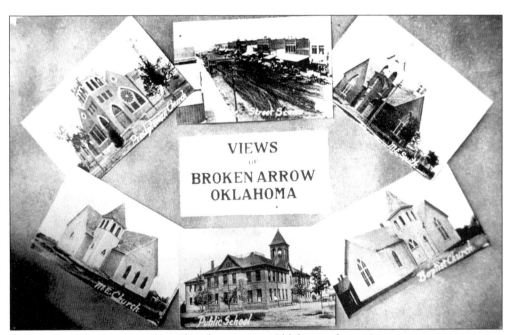

This postcard features six views of Broken Arrow, Oklahoma, from 1911.

This 1795 Map of Georgia shows the location of the Indian village of Broken Arrow.

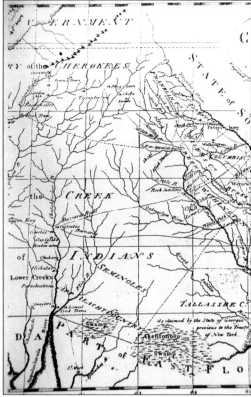

W.S. Fears (1869–1955), as secretary of the Broken Arrow Townsite Company, selected the place for this town, 1902.

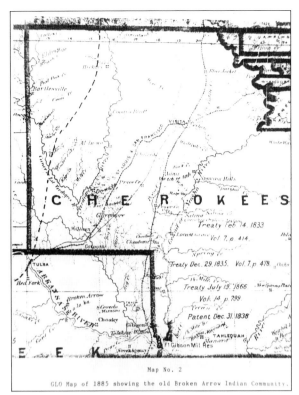

This General Land Office Map of 1885 shows location of the Indian village of Broken Arrow, Indian Territory.

Map No. 2

GLO Map of 1885 showing the old Broken Arrow Indian Community.

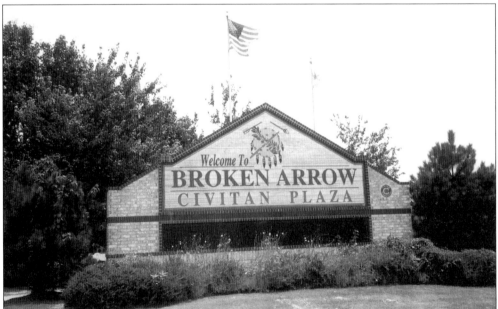

Civitan Plaza, located at North Elm Place and Kenosha Street, welcomes those entering Broken Arrow from the north. The three flags are the American flag, State of Oklahoma flag, and Broken Arrow city flag. Electronic messages appear in the blank space on the sign to announce events such as Rooster Day, Christmas Parade, Irish Festival, etc. There are also some rose bushes in this landscaped plaza.

Two
AGRICULTURAL CROPS

Principal agricultural crops in early Broken Arrow country were corn, oats, and cotton. Small amounts of wheat, rye, and barley were also grown. Beef cattle, swine, poultry, horses, and mules were dependable farm items. Excess eggs, cream, and butter were often traded for staple groceries. Beef cattle and hogs were a source of family meat and cash income. Apples and peaches were fruit items of importance as farm products. The dairy industry was important along with the chick hatchery business.

The following story was given by Bruce Reynolds to the author during an oral interview in March of 1987. His folks owned a farm in Illinois which they sold in 1904 and came to Indian Territory. The Reynolds family came to Broken Arrow by train and purchased a 200-acre farm from Fred Boles. The farm was located just west of the present Rhema Bible College. The Reynolds family raised corn as the dominant crop and fed cattle and hogs. They also milked 30 or 40 cows and hauled the milk in 10-gallon cans to a dairy processing unit in Tulsa. They did not raise cotton which was a crop grown south of Broken Arrow to Bixby. They had a large garden and canned their vegetables. They also had a large orchard consisting of peaches, plums, apples, and berries: strawberries, blackberries, gooseberries, and raspberries. They built a one-story house with four rooms in 1906. They had a cellar where they could take shelter in case of tornadoes.

In 1905 a gas well was drilled on their farm. Little gas was found, but the well turned out to be a strong water well. The town of Broken Arrow arranged to have a two-inch pipe extending from the water well to old City Hall. Therefore, the citizens of Broken Arrow had a better source of water than their city wells which were considered salty in taste. Since the Reynolds family boys were not interested in farming, everything was sold in 1920, except the land. The land was rented out to other farmers. Bruce Reynolds inherited the farm which he sold in 1965.

Corn was a major agricultural product in the Broken Arrow area. Sometimes corn production resulted in the grain elevators not being able to handle the surplus. The surplus corn would be stored in the open with a fence around it. Open areas along the KATY Railroad tracks would be used for the temporary storage of corn.

The town of Broken Arrow was established in land where thousands of cattle were grazed on the prairie grasses on the adjoining ranches. As more settlers arrived and made arrangements to

either buy or lease the lands owned by the Muscogee (Creek) Nation, the large cattle pastures became smaller. The settlers could raise corn and use this item to feed their cattle and horses. So the day of the cattlemen eventually disappeared in Indian Territory and their operations moved west and into the Cherokee Outlet. Later these lands were allotted to the Plains Indians and the other lands were open for settlement by the white homesteaders. The large-scale cattle ranches in Oklahoma Territory ceased to exist. The shipment of local cattle, horses, and mules was done at the cattle loading pen adjacent to the KATY Railroad tracks, just east where South Main Street crossed the tracks.

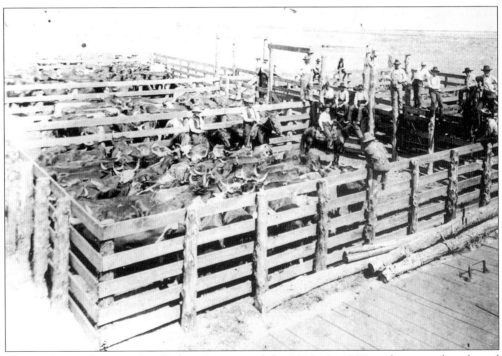

This cattle corral was used in Broken Arrow until the 1940s. In 1920 twelve cars of cattle and three cars of mules were shipped by railroad. Today there is no trace of the cattle corral in Broken Arrow.

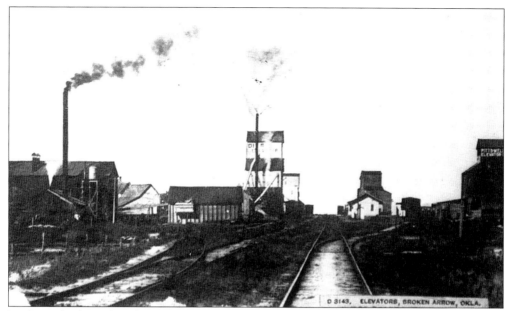

In the early days of Broken Arrow, there were four grain elevators along the KATY Railroad tracks. Note that two of the grain elevators have smoke exiting from their stacks. These elevators ran on steam since there was no electricity in Broken Arrow until 1906. This business was important to Broken Arrow since the local farmers raised large quantities of corn and some wheat. There were several grain elevators over the years. Among the first were Bower-Brown in 1903; Jamison and Baxter in 1904; Dix Elevator Company in 1905; Pitts-Wells Elevator Company in 1906; and Stevens Scott Grain Elevator Company. W.E. Curnutt and Son purchased the Fox and Jaynes Mill in 1908, which later became known as Broken Arrow Milling Company.

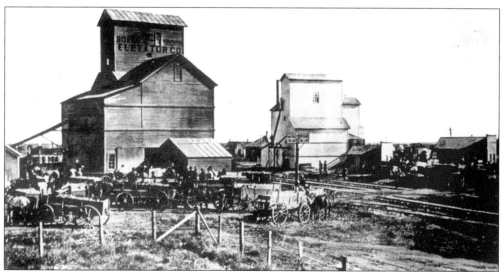

This grain elevator was owned by Dr. J.W.S. Bower and George A. Brown. They also owned grain elevators at Porter, Coweta, and Alsuma. There are a number of teams and wagons filled with corn awaiting their delivery. Across the railroad tracks is the Jamison and Baxter Grain Elevator and Grist Mill, which later became known as the Hannifer Mill and Elevator Company.

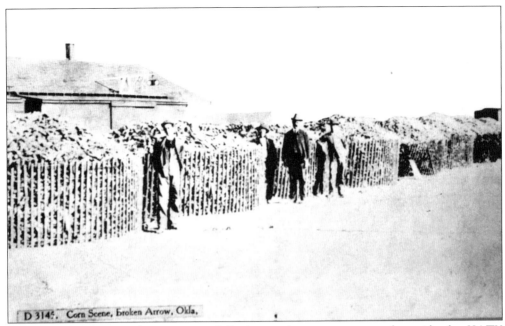

D 3145. Corn Scene, Broken Arrow, Okla.

When the local grain elevators were full, the surplus corn was stored outside the KATY Railroad Depot using the circular wooden fence to contain the corn until it was shipped by rail. In 1920, 95 cars of grain were shipped from Broken Arrow.

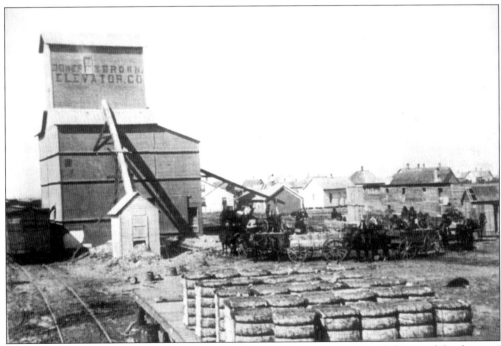

The Bower-Brown Elevator has a number of teams and wagons awaiting delivery of the farmers' corn. In the foreground are a number of bales of cotton on the KATY Railroad Depot platform waiting shipment by railroad.

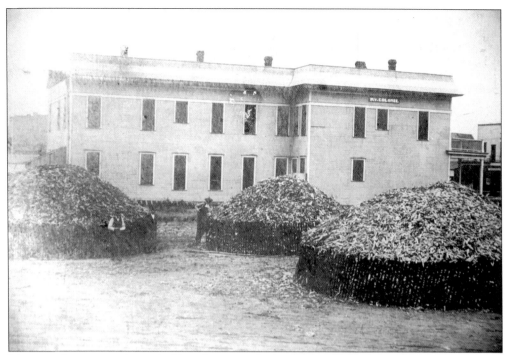

More surplus corn is shown held in fences at the Kentucky Colonel Hotel in Broken Arrow, 1908.

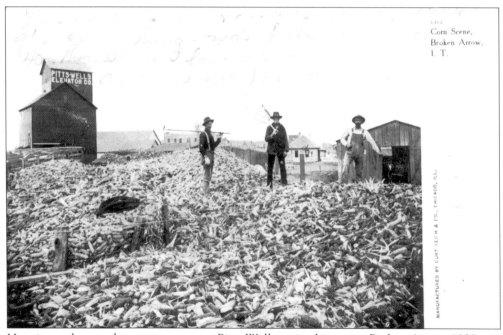

Here is another surplus corn scene near Pitts-Wells grain elevator at Broken Arrow, 1908.

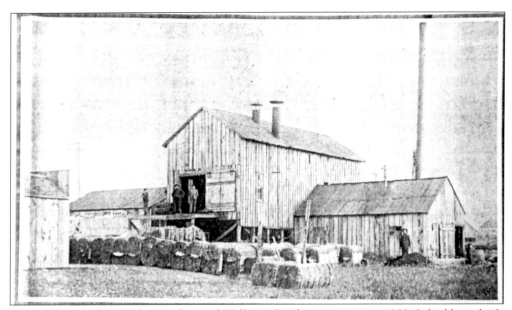

Pictured here is the Brooks, Sanders and Williams Brothers cotton gin, 1903. It had been built at the hamlet of Elam in 1901. When the KATY Railroad tracks were constructed 4 miles north, the cotton gin was moved to Broken Arrow in 1903.

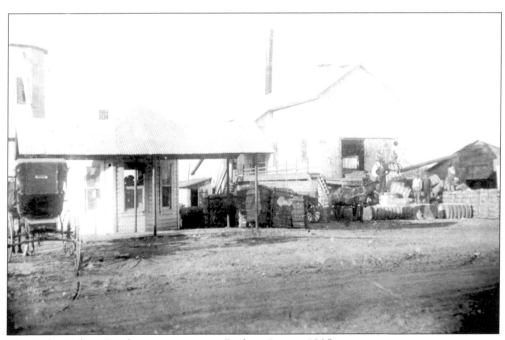

This is the Dalton Brothers cotton gin at Broken Arrow, 1905.

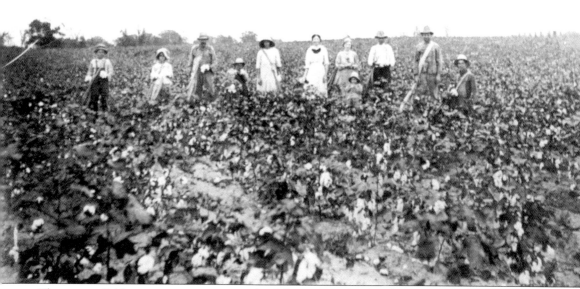

The cotton field was a major crop in much of the area south of Broken Arrow until 1951. The raising of cotton was a labor intensive use of manpower. Hence large families, such as the Keeles, shown here, would pick the cotton when it was ready in the fall. In this view, you can see historic White Church in the upper right portion of this photograph, 1915.

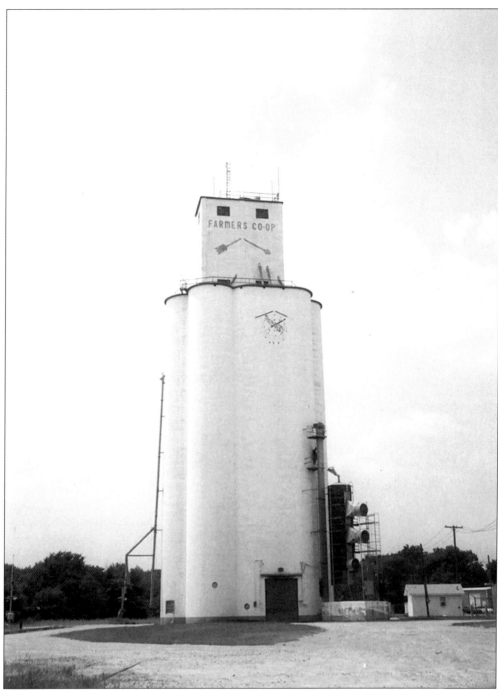

Pictured is a modern grain elevator built in 1958 by the Farmers Cooperative of Broken Arrow. This concrete structure is about 150 feet high. Today, the Hampton-Mueller Company leases the facility. When full, the grain elevator can hold 153,000 bushels of wheat or 205,000 bushels of oats. There has been no rail service since 1976. The wheat or oats are brought by trucks and stored in the elevator. It is an interesting fact that oats are purchased from Sweden and brought by ship to either New Orleans or Houston ports, and then by barge or truck to Broken Arrow.

Three
LOCAL INDUSTRIES

The Arkansas Valley Township Company had a subsidiary, Adams Creek Coal Company, which mined the coal deposits east of Broken Arrow as early as 1902. Most of the early work was done by man and a mule pulling a road slip. At first only picks, shovels and dynamite were used to extract coal. In 1903 a spur railroad track was constructed to the coal mines. By 1905 coal was being mined and delivered to Broken Arrow at $2.50 per ton. Sixty teams and one hundred men were employed in 1905, and 980 cars of coal (39,000 tons) were shipped by rail. As the demand for coal increased, more modern methods of stripping coal by steam shovel were used. Various names of local mines were Adams Creek Coal Company, Broken Aro Mine, Weir Mine and Seneca Coal Company. In 1928 there were 2,436 cars of coal shipped. Coal open-pit or strip mining operations near Broken Arrow had ceased by 1940.

The Seneca Coal Company attempted to interest the town of Broken Arrow in perhaps making some of its mining spoils into a park. Broken Arrow was such a small town in 1940, with a total population of only 2,024, and the town fathers never thought that the town might grow larger in the future. Mr. Russell Kelce of the Seneca Coal Company approached the Broken Arrow School District about giving them some of the property, but they were not interested in his proposal. Forty acres were offered to the local Boy Scout Troop 104 of Broken Arrow. They accepted his proposal, cleaned up some of the area and built a Scout training camp. Mr. Russell Kelce was so pleased with their activities that he offered them an additional 395-acre tract for their exclusive use. A conservation program was initiated by planting evergreen seedlings on the coal mine tailings. Fish were added to the waters of Broken Arrow Creek. A swimming pool and other amenities were added to the camp. Later, in 1994, when the courts had cleared title to the Camp Russell area, the City of Broken Arrow purchased some 240 acres of the eastern portion of Camp Russell; and this became the site for the new Northeastern State University campus at Broken Arrow. Other parts of Camp Russell have been greatly improved with a grant from the Robson Family Enterprises. Camp Russell is under the jurisdiction of the Indian Nations Council of the Boy Scouts of America.

Wooden derricks were used to drill and extract oil and gas in the Broken Arrow area, but no great pools of oil were discovered. Forty-five oil wells and twenty-five gas wells were producing locally in 1920. There were four casinghead gasoline plants in this vicinity. The oil activity

employed many of the local people during the 1920s. Today a few of the oil wells are operated by stripper pumps. The barrels of oil are pumped into metal reservoir tanks which are emptied regularly by trucks into their tankers. The Hillenburg Pipe and Supply Company of Broken Arrow owns ten pumps around the vicinity of County Road and East Florence Street. These pumps operate 24 hours a day and their oil output is piped into the nearby holding tanks. Oil was found at around 1,800 feet in this area.

John W. Smoot and William R. Sullivan established a brick factory in Broken Arrow in 1904. It was located west of North Elm Place and the KATY Railroad crossing.

Today there are several industrial parks in and around the City of Broken Arrow. Some examples of businesses there are as follows: FlightSaftey International, Baker Oil Tools, Bryan Adair Construction, Arrow Concrete/Tulsa Dynaspan, Braden-Carco-Germatic, Blue Bell Creameries, Cameron Glass, Paragon Films, XETA Corporation, Mill Creek Lumber & Supply Co., Wal-Mart, Valor Telecommunications, Southwest Laboratory of Oklahoma, Air Cooled Exchanges, Inc., and Addvantage Technologies Group.

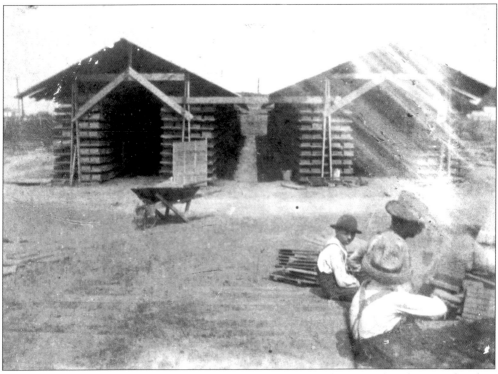

Two kilns, each 25 feet in diameter and 15 feet in height, are shown in this photograph. They were gas fired. The clay for making the bricks came from a local creek near the kilns. Their end product was known as a soft brick. The Superintendent's Home, at Haskell State School of Agriculture, was built of Sullivan brick. It is located at College Avenue and North Fifth Street, across the street from the old Haskell School campus, now the Broken Arrow North Intermediate High School campus.

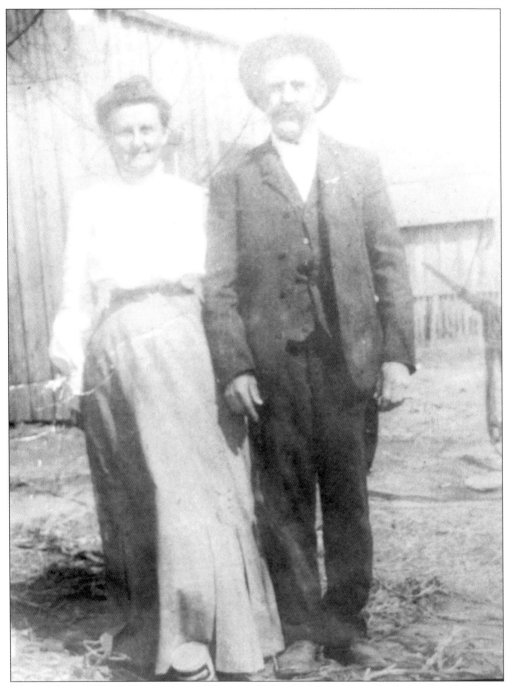

Mr. and Mrs. W.R. Sullivan, pictured here in 1904, died in a tragic death in a hotel room in Oklahoma City in 1923 as a result of a poorly-vented stove. They were the grandparents of Elsie Esslinger of Broken Arrow.

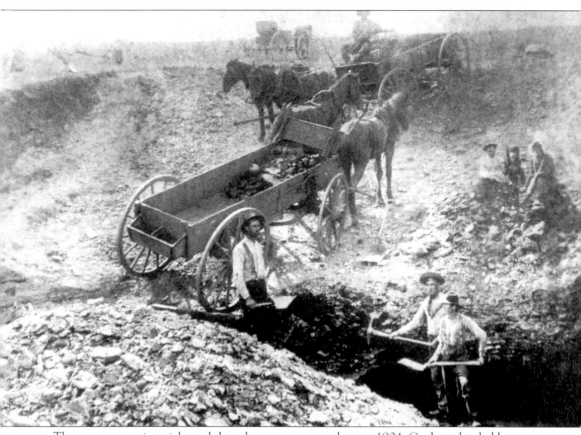

These men are using picks and shovels to extract a coal seam, 1904. Coal was hauled by wagon to a railroad stop or sold house by house in town settlements.

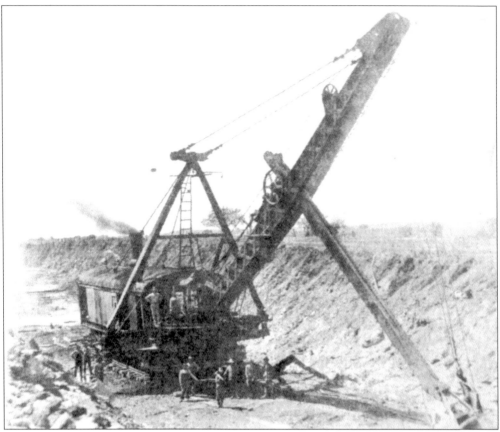

The first Steam Coal Shovel in Broken Arrow was called "Old Valcon Steam Shovel." Note the cut in the ground left by strip mining activities, 1910.

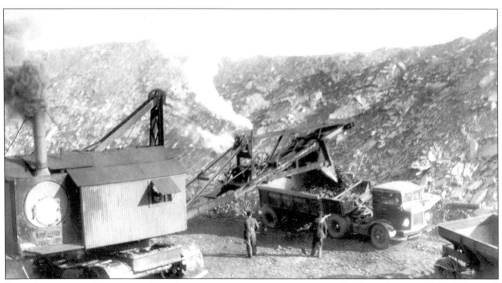

Seen here is another steam shovel operation in strip mining near Broken Arrow, 1910. The coal shovel is loading coal in trucks, which will haul to a railroad loading area.

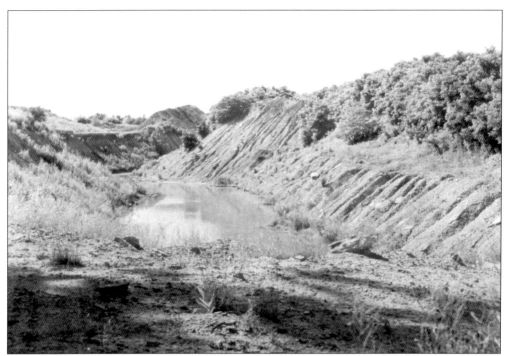

The open cut in the land, water and spoils were left in the old strip mining process. Today an operation such as this would be required to level the area and to plant grass in the processed field.

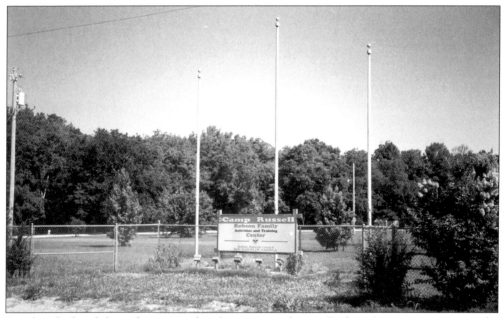

Four hundred and thirty five acres of coal mining spoils near Broken Arrow were given to the Boy Scouts of America. The Robson family has generously donated funds to build shelters and rest rooms in this area. It is now used for training Scouts in outdoor skills and activities. They sold 240 acres to the Northeastern State University to establish a campus at Broken Arrow.

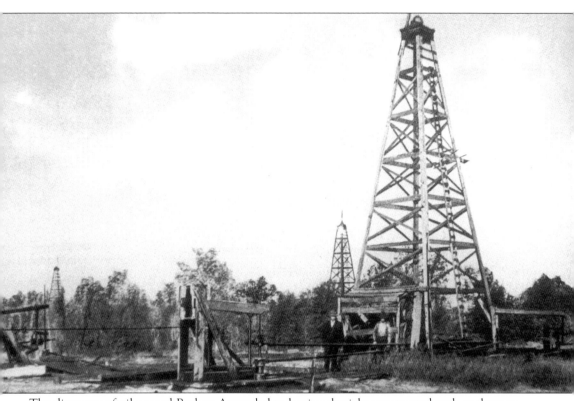

The discovery of oil around Broken Arrow led to having derricks constructed such as these to locate the oil deposits. No great discoveries were found around Broken Arrow, but some oil and gas wells continue to produce.

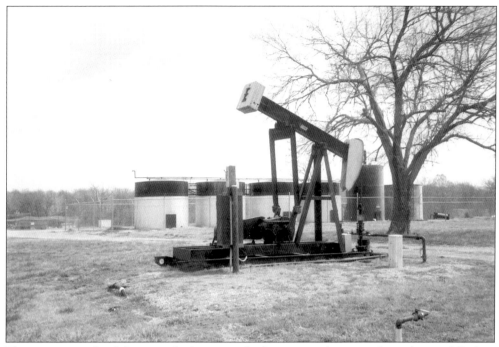

This is an example of the type of oil pump and oil storage tanks currently used around Broken Arrow.

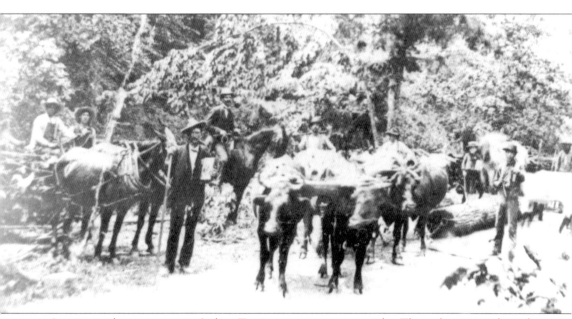

Logging with oxen teams in Indian Territory was a common sight. The walnut trees along the Arkansas and Verdrigis Rivers were cut and hauled by oxen teams to the nearest railroad depot. Walnut was shipped to Europe where it was used in furniture making.

Four
Broken Arrow Town Scenes

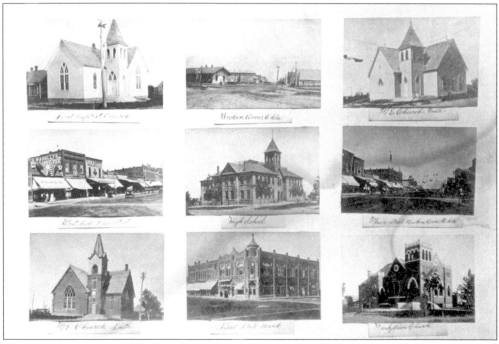

The business portion of Broken Arrow started at the KATY Railroad tracks and continued north along Main Street until it reached the Methodist Church on College Street. This view shows nine different buildings in early Broken Arrow, which include four churches, one public school, First State Bank, two downtown shopping areas, and the KATY Railroad Depot.

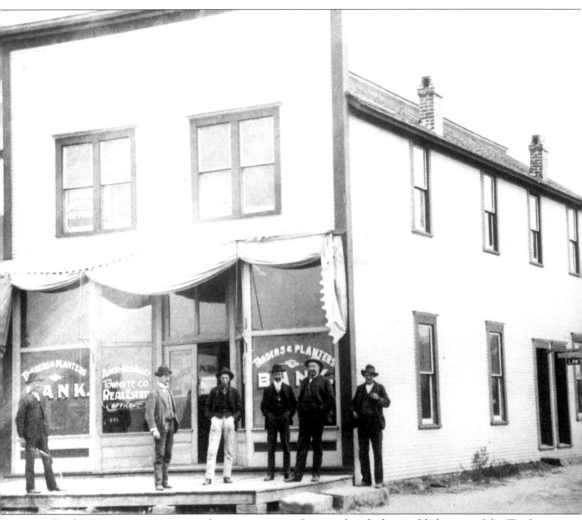

Banking was a very important business venture. It started with the establishment of the Traders and Planters Bank, which was founded in December of 1902. This bank later became the First National Bank of Broken Arrow. Local banks survived hard times and mandatory holidays. In 1907 the state declared bank holidays to offset hardships caused by holidays in surrounding states. By the end of 1907, when the panic had passed, all banks of Broken Arrow had resumed full cash payments to depositors upon demand. Both First National and Arkansas Valley are thriving businesses today, greatly expanded from that first decade on Main Street, with diversity of services.

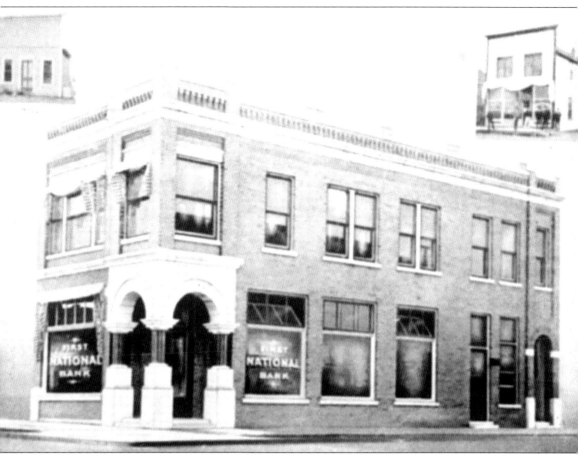

First National Bank of Broken Arrow has remained in its original location, with modern expansion to include most of the block.

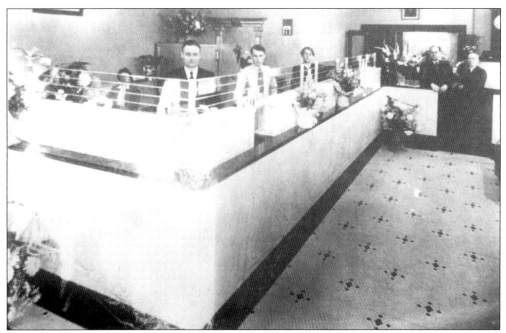

The lobby view of the First National Bank includes several floral displays and Mr. F.S. Hurd. First National Bank was prudently managed by F.S. Hurd and other officers and held in high regard in the community. This bank gained strength during the depression by joining Southwest Corporation with a group of 20-30 banks in the state, sponsored by the conservative Exchange National Bank of Tulsa.

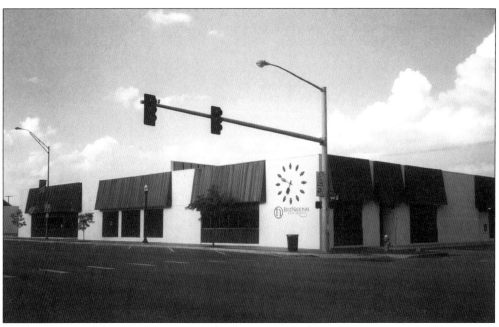

A current view of the First National Bank contrasts with the past.

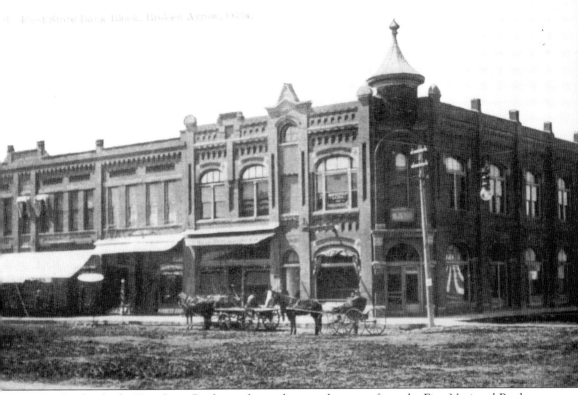

Another bank, the First State Bank, was located across the street from the First National Bank. Its charter also dates back to 1902. Later this bank changed its name to Citizens National Bank. In October of 1922, Citizens National Bank was sold to the First National Bank and to the Arkansas Valley State Bank. The two remaining banks guaranteed payment to depositors of Citizens, and accounts of those depositors were transferred to the two banks. The reason for the consolidation was that Broken Arrow business did not justify three banks. Both banks issued money on printed sheets. Local officers signed the first bills—F.S. Hurd at First National Bank and John F. Darby and Cashier Guy Bowman at the Arkansas Valley State Bank.

On July 24, 1934, an attempt was made to rob the First National Bank. Two men wearing bib overalls, dirty and with beards of two or three weeks growth, entered the front door of the bank. Mr. F.S. Hurd and fellow Burge were on duty behind the counter. One of the robbers said, "Take it easy boys here is where we get you!" Mr. Hurd reached for a pistol and said, "I don't believe you will!" Mr. Hurd then pointed his pistol at the robber, fired, and hit him. He fell to the floor and the other man at the front took a shot at Mr. Hurd, but missed him. Both men were lying on the floor next to the counter. They played a waiting game, but eventually a man got up and assisted his partner out of the front door. There they got into an automobile which was waiting and sped off into the town.

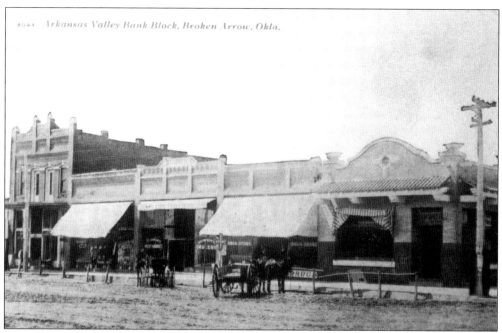

The Arkansas Valley National Bank was established in 1905. This bank changed its name to Arkansas Valley State Bank after statehood.

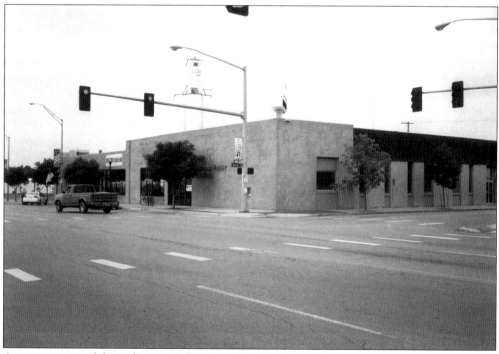

A current view of the Arkansas Valley State Bank is shown for contrast.

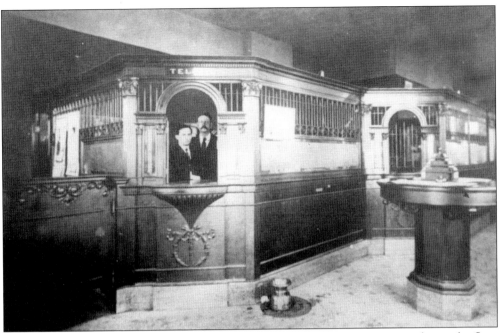

A view of the lobby in the Arkansas Valley State Bank shows a prominent cuspidor on the floor to the right of the Teller's Window. The Depression was survived at the Arkansas Valley State Bank because of prudent management of K.M. Rowe, the reputations of the bank and of Rowe in the community, and confidence depositors had in the bank. Also being a state bank was an asset. The state banking association established a Guaranty Fund which gave additional contentment to depositors. There was no FDIC at the time.

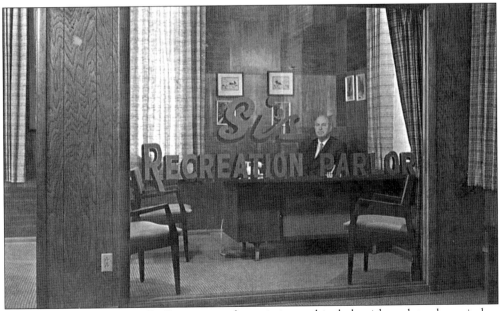

Another view shows Ivan D. Brown, president, sitting at his desk with a plate glass window reading "Si's Recreation Parlor." This plate glass was moved from the adjacent Pool Hall into which the bank expanded.

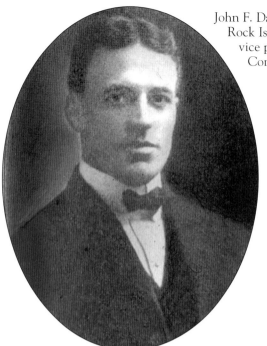

John F. Darby (1872–1953) was president of the Rock Island Trust and Investment Company and vice president of the Arkansas Valley Townsite Company.

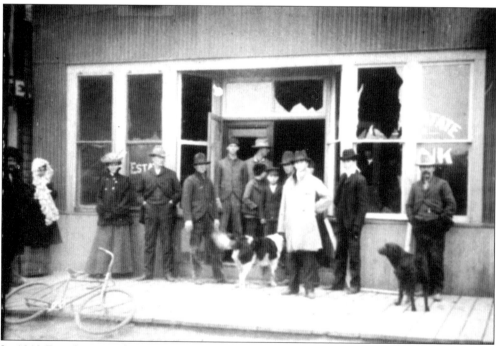

In 1912 First State Bank was robbed after an explosion that woke everyone in town and blew out the bank's windows, as evidenced by this photo. The robbers ran to the railroad track, got on a handcar and headed toward Tulsa. All they got was a package of nickels that were lying on top of the safe. They ruined the safe because they blew it open with nitroglycerin, but never got the second door open.

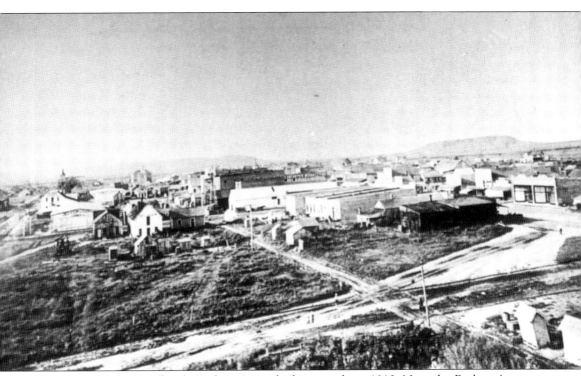

This is an aerial view of early Broken Arrow looking north, *c.* 1910. Note the Broken Arrow Mound (now Tiger Hill) at the upper right portion of view. The church with steeple at left is M.E. Church, South. The next tall structure is the Public School building. The edge of the building to the extreme right is the Kentucky Colonel Hotel with two outhouses.

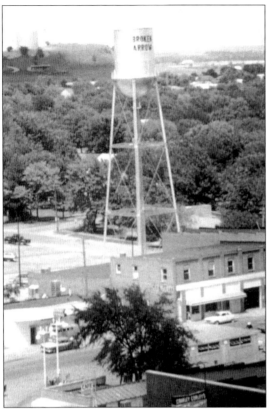

On June 29, 1903, the citizens of Broken Arrow elected their first town council. The council met in rented quarters until their new two-story brick building was completed in 1910. This building housed the fire department, police department, a clerk's office, city council meeting quarters, a library, and a jail; and it also served as a meeting place for the Boy Scouts of America troop.

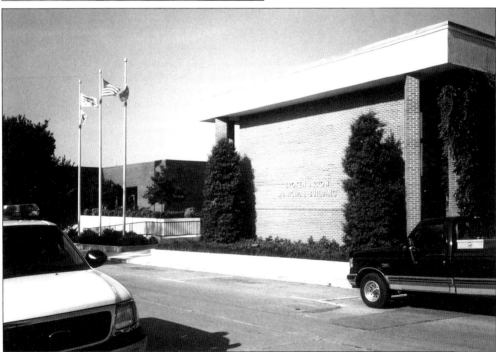

The present Municipal Building was completed in 1982 at 200 South First Street.

In 1909 the citizens of Broken Arrow voted to have a new water system. An 8-inch water line connected the City Springs leading to the water tower next to City Hall. City Springs was called by the Creek Indians *Age-e-nie*, which means beautiful water. Hence: "Broken Arrow, City of Roses and Sparkling Spring Water." The capacity of the spring was half a million gallons every 24 hours. The pump house was 16 by 14 feet and contained the motor and pump. Water then was pumped through an 8-inch pipe to the stand pipe or water tower.

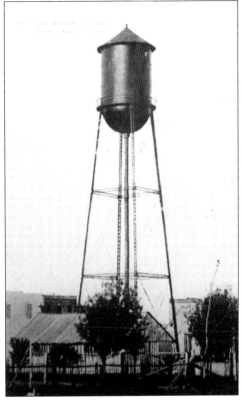

The old spring is in Ray Harrel's Nature Park, seen here in 1910. Today Broken Arrow's water comes from the Verdigris River.

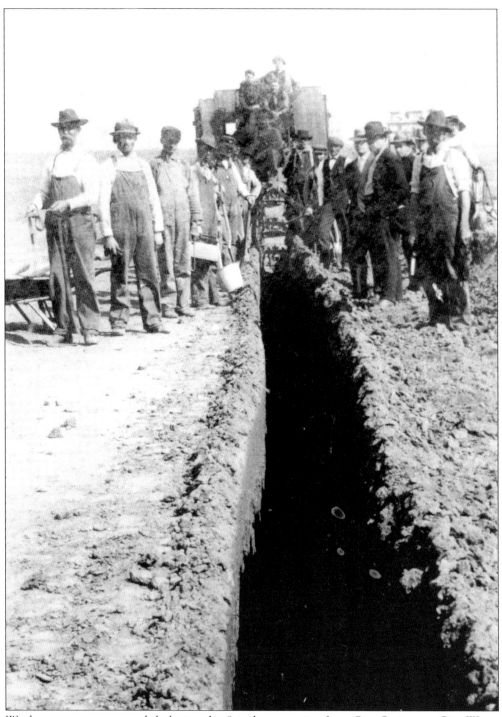

Workmen pause to pose while laying the 8-inch water pipe from City Springs to City Water Tower.

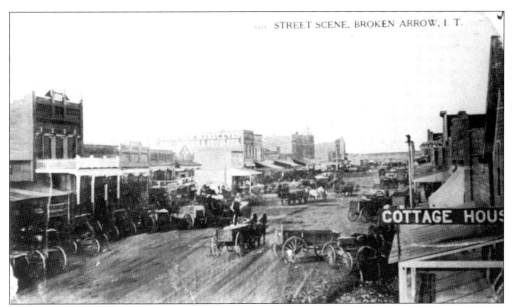

This busy street scene of Main Street looking north shows the Cottage House hotel, with horses and wagons. The two-story brick building on the west side of street has the following name on the side of the building: "Lancaster, McAnally Company Dry Goods-Groceries."

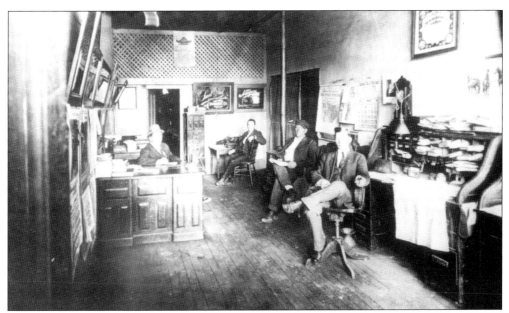

The Williams Brothers Real Estate and Insurance office was located on Main Street in Broken Arrow. Merida Caleb "Mac" Williams is seated on the left. William "Newt" Williams is seated in the chair in front. The Williams brothers came from Arkansas to Indian Territory in April of 1901 and established a hamlet, known as Elam. They had a dry goods store, a post office, and a cotton gin. They had built two residential homes for their families. When the KATY Railroad tracks were constructed four miles north at Broken Arrow, the Williams brothers decided to move their dry goods store and cotton gin to Broken Arrow. They also moved their two new homes to Broken Arrow in 1903.

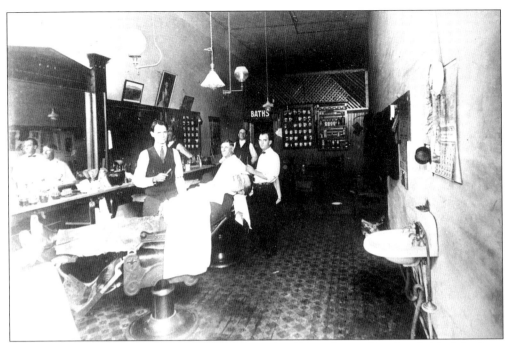

The Cuddy Barber Shop was located on the west side of Main Street. Standing behind the front chair is Lee Phillips, barber. Behind the second chair is Roy Cuddy, barber, with customer J.A. Barth. The man in rear of building is unidentified. Note the gas lights, a "bath" at the rear of building for 25¢, and a rack containing shaving mugs.

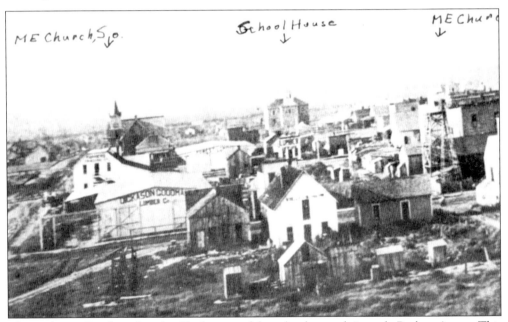

The Dickason Goodman Lumber Yard is one of three lumber yards in early Broken Arrow. This lumber yard was located west of Main Street and north on West Dallas Street. It provided materials for the construction of new businesses and homes. Note the windmill behind the building at the extreme right.

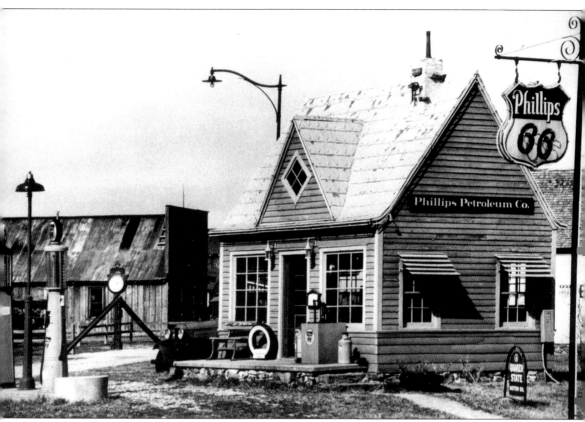

The Phillips 66 Gasoline Station was located on the East Dallas Street near the intersection of Main Street. There are two hand-operated gasoline pumps in front of the station. There is a 1931 Ford truck parked by the station. Today this site is part of the parking lot for the Credit Union. To the left of the station is the oldest business office in Broken Arrow—National Realty, sold lots in Broken Arrow Townsite.

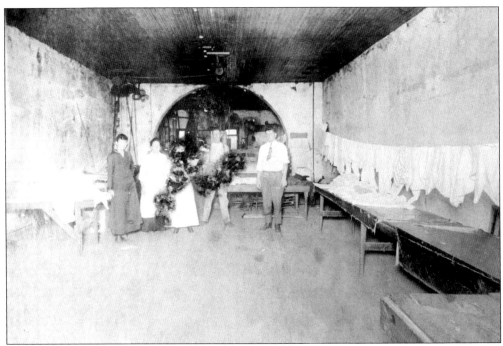

Dunbar's Laundry was located at Main Street and Broadway. Jim Dunbar, a World War I veteran, lived upstairs.

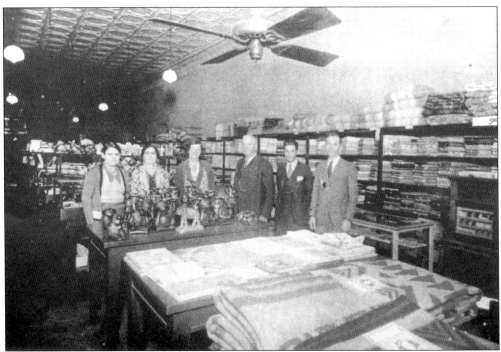

Hunsecker's Dry Goods Store was located on Main Street and West Dallas Street. This 1929 photo shows, from left to right, Ora Benedict, Mrs. Akers, Mrs. Blynn, Dad Hunsecker, Clive Srader, and E.J. Gormley.

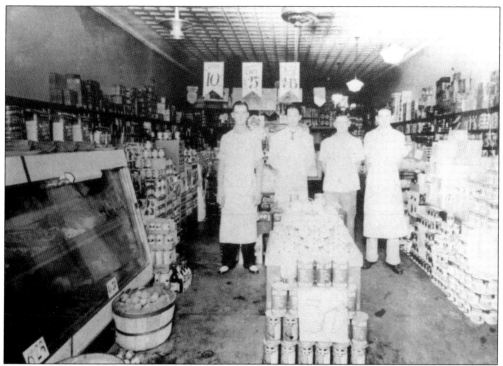

Lloyd's Grocery Store was located at 214 South Main Street. Pictured here, from left to right, are Claud McCain, Shortie Hall, William Finley, and Bill Chapman.

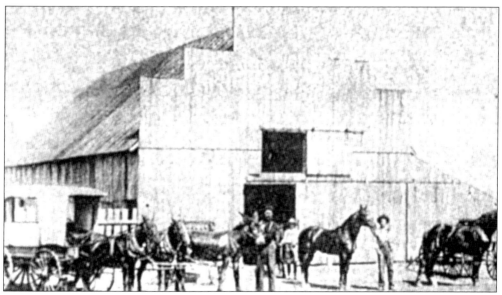

The livery stable business was built by E.M. Arnold and run by W.A. Markhan. It was located on the east side of Main Street north of the grain elevators and railroad tracks. Rigs were provided with drivers, if requested. Horses were bought, sold and exchanged. This business also boarded horses for private parties.

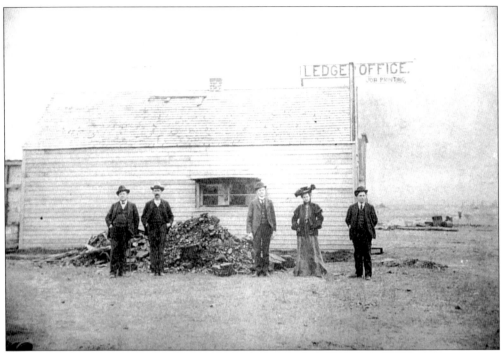

The *Broken Arrow Ledger*, local newspaper, was founded on April 23, 1903, by Michael McKenna, editor. The printing press was set up in a small back room of the First State Bank. Later the Ledger had its own building. Therefore, the *Broken Arrow Ledger* is the oldest newspaper in Broken Arrow—it continues to publish after almost 100 years of operation.

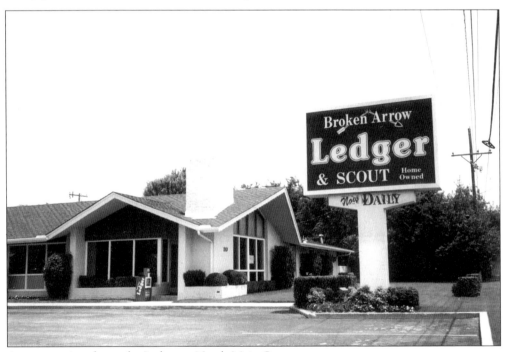

A current view shows the Ledger at North Main Street.

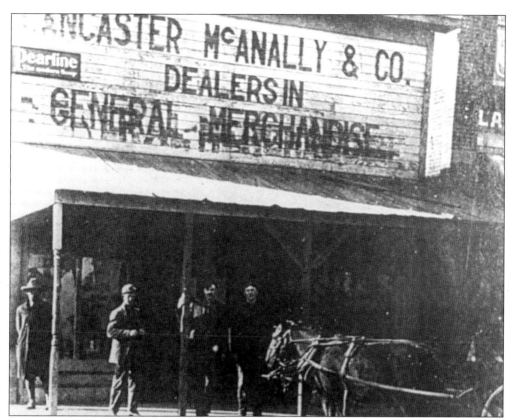

Lancaster McAnally & Company was a dealer in general merchandise. This store was located on the west side of South Main Street. They had a well dug behind this store reaching ground water at 75 feet.

Tucker's Barber Shop is located immediately on the left, then Naifehs Store and Nill's Grocery & Mkt. The Barnsdall Station at the extreme right is the location of the new Centennial Park to be dedicated on October 19, 2002.

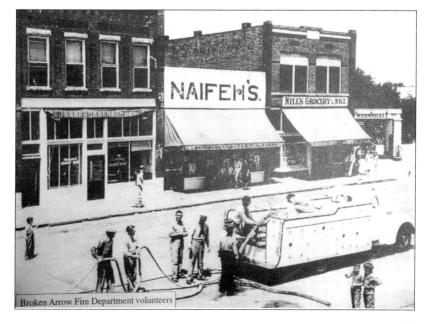

Broken Arrow Fire Department volunteers

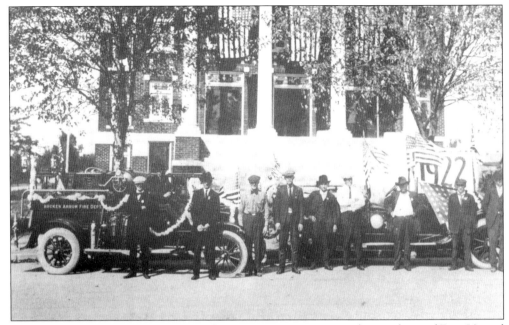

Pictured here is the Broken Arrow Volunteer Fire Department, taken in front of First United Methodist Church, 1922.

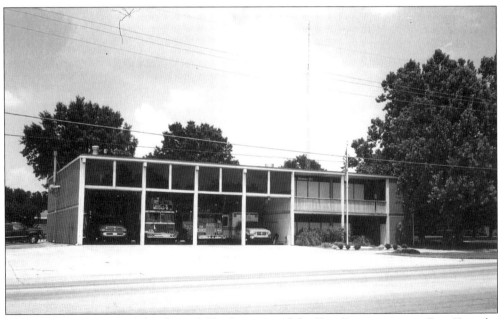

This is a current view of the Central Headquarters of the Fire Department on East Kenosha Street, 2002.

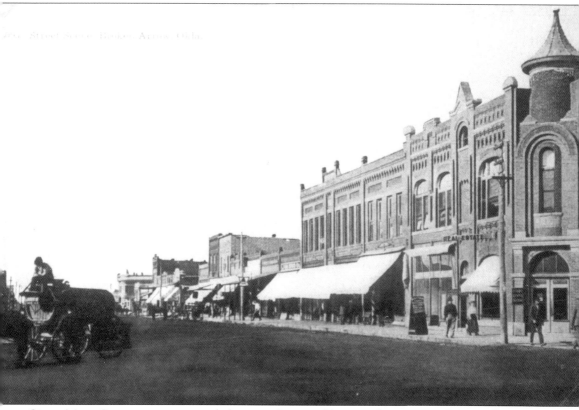

Since Main Street was not paved, hot weather would cause dust storms. E.H. Hall was authorized to operate a street sprinkler to keep dust down, which was a horse-pulled tank of water. Water was obtained from a well at Braden & Son and pumped by a gasoline engine into a tank. Broken Arrow finally got its first paved street when State Highway 51 was constructed down Main Street.

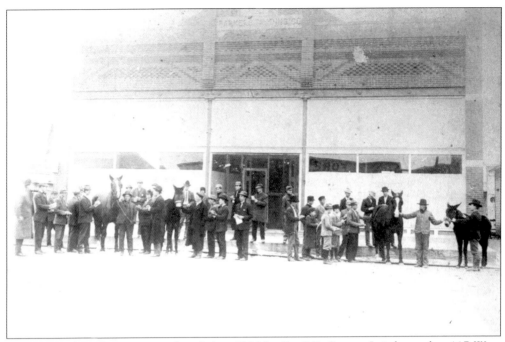

Farmers Trading Company was founded in 1906 by Dr. S.E. Orcutt. It is located at 117 West Commercial. This store specialized in clothes and shoes. Note the men in front of store with four horses and mules being offered for sale.

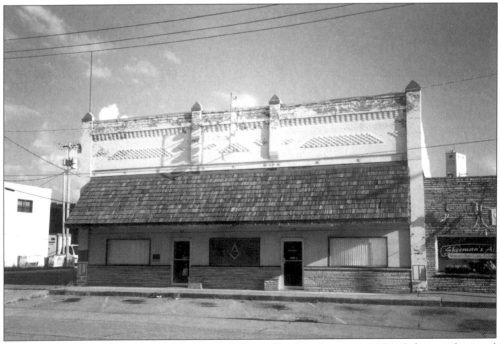

This building was acquired by the Masonic Lodge of Broken Arrow in 1974. Other professional organizations using this meeting hall were Eastern Star, DeMoley, Rainbows, and Job's Daughters.

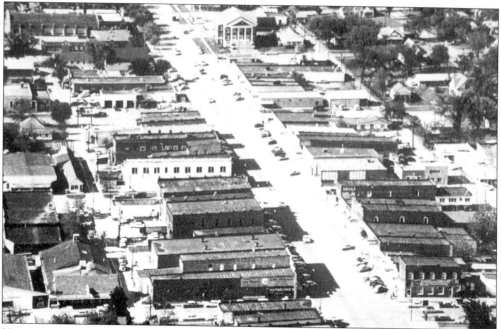

Here is an aerial view of north Main Street up to the 1920 M.E. Church building with columns.

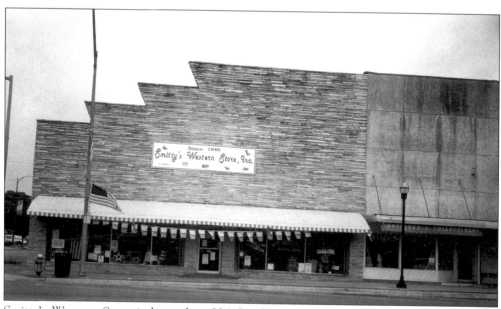

Smitty's Western Store is located at 224 South Main Street. As part of Broken Arrow's Centennial Celebration, a mural contest is being done by students of Broken Arrow. They will use the south wall facing the Arkansas Valley State Bank for the mural.

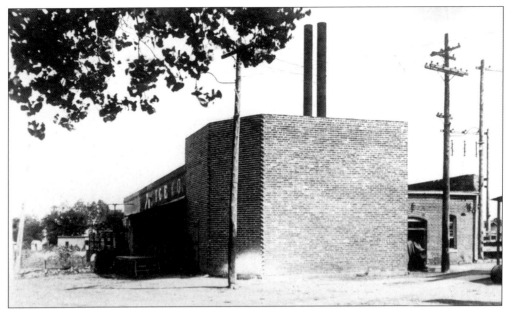

In 1906 the Broken Arrow Light Company was granted a franchise to provide electricity to the town. In 1917 the electric plant was purchased by the Public Service Company of Oklahoma. An ice plant was developed in 1906 by J.D. Shubert, who advertised that he delivered ice daily to homes and businesses in Broken Arrow. This service was discontinued in 1947.

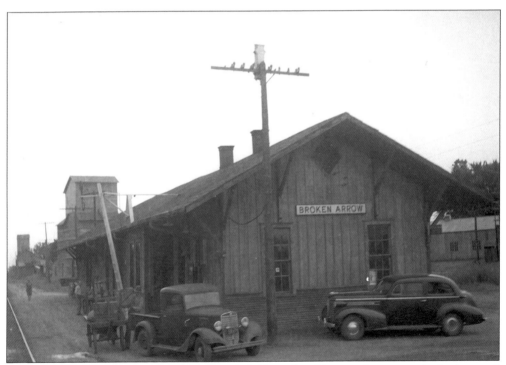

Shown here is the KATY Railroad Depot, 1940. Note the old grain elevator in the background and the styles of vehicles in the foreground.

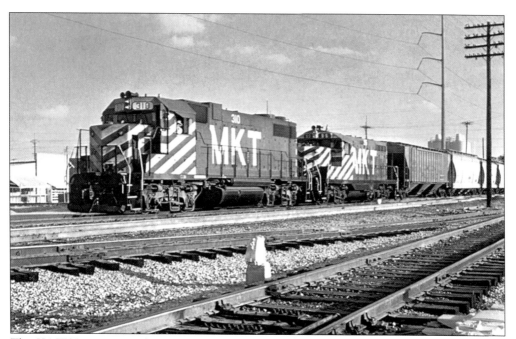

This KATY Locomotive shows its true colors—yellow & green. The Union Pacific acquired the Missouri, Kansas and Texas Railroad track on August 12, 1988, which runs through Broken Arrow.

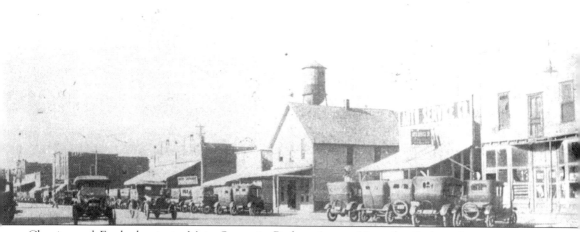

Chevies and Fords dominate Main Street in Broken Arrow. Note the Broken Arrow water tower in the background.

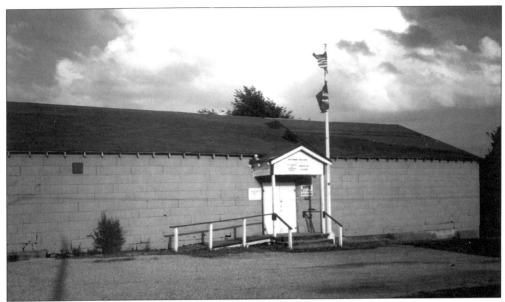

The Veteran's Building is located at East Commercial and North 5th Streets. Operated by the American Legion and Veterans of Foreign Wars, the original building came from Camp Gruber.

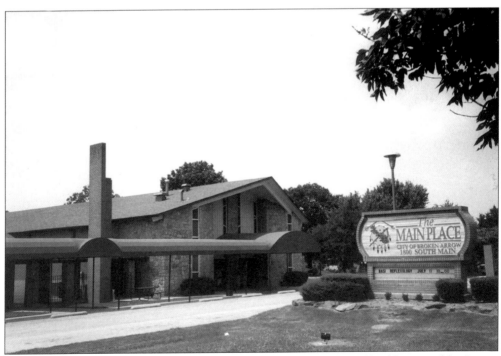

The Main Place, located at 1800 South Main Street, is a complex of buildings used by Senior Citizens, the Community Playhouse, and a historical museum and genealogical library.

Five

EDUCATION

There was no school in Broken Arrow during the first year of existence. The following citizens were elected on August 25, 1903, to the Broken Arrow School Board of Education: G.L. Holt, president; N.L. Sanders, secretary; I.M. Thompson, Thomas Blair, S.E. Orcutt and H.L. Pierce. J.D. Thomas was selected to be the enumerator for the April 1904 School Census of Broken Arrow. The first school census of Broken Arrow included the names of the individuals, their age, sex, and race (White, Indian or Negro) and their place of residence by street, block and lot number.

The Town Council met on Monday evening, June 20, 1904, for discussion and voted to levy a two percent tax on the property holders of the town in order to generate some revenue to pay bills, meet current expenses for the year, to permit the School Board of Education to erect a suitable school building, supply the same and to employ efficient teachers.

On June 27, 1904, Guy Bowman of the Arkansas Valley Townsite Company signed a warranty deed to all of Block 30, opposite the Methodist Church. The deed was given to the Broken Arrow School District with the provision that should there ever be a county seat established in Broken Arrow, this Block 30 shall be deeded by the School District to the County. A further stipulation provides that there shall be a stone or brick building erected on it of not less than two stories in height.

The Town Council passed Ordinance No. 26 on June 27, 1904, relating to a levy of taxes for the Incorporated Town of Broken Arrow, Indian Territory, for the year 1904. Its purpose was to maintain the government of Broken Arrow and for creating a public school fund for this town. A sum of $4,500.00 was established for the School District of Broken Arrow.

A Notice of Contractors appeared in the Broken Arrow Ledger for plans and bids for the erection of the school building. There were five bids submitted for the construction of the new public school building. The lowest bid was for $4,343.00, which was submitted by Martin Sanders and W.F. Waller. The Broken Arrow School Board accepted this bid and awarded the contract to Sanders and Waller. The School Board then solicited funds from 15 individuals and local firms of $100.00 each to be repaid when the School District Funds were available.

The new school building was to contain four rooms, each 25 by 40 feet in size, with 12-foot

ceilings. There were to be two lower and two upper rooms. The main building would be 42 by 52 feet in size, with an annex, 20 by 20 feet, to contain cloak rooms and to sustain the cupola. The stairs would also be in the annex and the top of the cupola would be about 50 feet above the ground.

The first free public school in Broken Arrow opened on October 5, 1903. The first school was held in the Methodist Church since it was the only building available. This first school enrollment included 179 children.

In 1907 the State of Oklahoma decided to establish three state normal schools in eastern part of the State. The citizens of Broken Arrow worked hard to obtain one of these normal schools. They achieved their goal and agreed to purchase 80 acres for the school site and a citizen's committee of 21 men put up a bond to secure a loan from the town of $3,466.77. Some buildings in Broken Arrow were rented so the first classes could proceed. Five faculty members were recruited and on the first day of school on November 9, 1909, 103 students were enrolled. Classes for 7th and 8th grades were offered as well as four years education of high school level. School opened October 9, 1909, with a full attendance of 105 pupils. The large two and one-half story barn was completed before the school building. Short courses were offered during the following years. These were for the purpose of introducing newer methods of cultivation and grains as products adaptable to Oklahoma soil. Examples were corn culture, dairying, butter making, stock judging, cooking, and sewing.

Haskell was closed in 1917. This was a political decision made by the state government. The Haskell Building was given to the Broken Arrow School District and was used as a classroom from 1918 to 1987. The Broken Arrow School District authorized the demolition of the Haskell Building in 1987.

The Broken Arrow School District continued to expand by discontinuing the rural schools and bringing these students into the school system in Broken Arrow. The Broken Arrow Schools of today educate nearly 15,000 students on 22 school campuses.

Guy Bowman (1871–1918) was president of the Arkansas Valley Townsite Company.

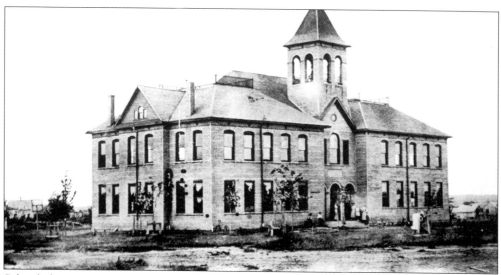

School classes met in the newly completed Public School Building on November 9, 1904, with an enrollment of 261 pupils.

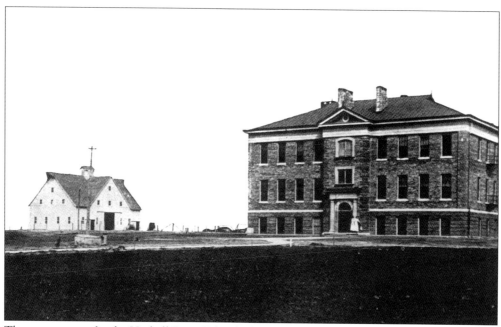

The cornerstone for the Haskell State School of Agriculture was laid on May 25, 1910. A three-story brick building was erected. It had 14 rooms and was centered on the 80 acre tract purchased for this school. The purpose of this school was to provide young people mental and manuel training in arts and sciences, including agriculture, mechanics, business methods and domestic economy.

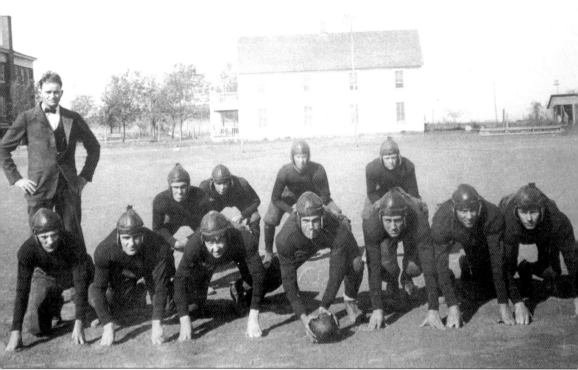

The Haskell State School of Agriculture had a football team. In 1911 this team won all their home games and were not scored upon. They also played Bacone Indian School, Tahlequah Teachers College and the Oklahoma A. & M. College "B" Team. The defeat of the Aggie "B" Team was credited for putting Haskell on the map. The football coach, seen here standing to the left, is Professor R.K. Robinson. Team members, pictured from left to right, are (front line) Thomas Hunter, Winton Hayes, Aubrey Stringer, Tacey Hunsecker, Ernest Hunter, Cecil Rhinehart, and Lucky Walton; (backfield) Collins Laws, Burnham DeWeese, Thomas Stringer, and Wesley Grube.

The Central School was built in 1925 on the same site which the 1904 public school building was located.

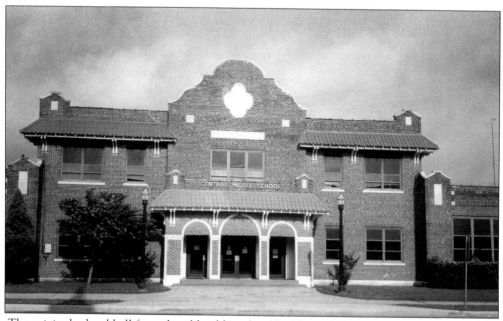

The original school bell from the old public school building of 1904 is hung on a metal rack at the southeast corner of the Middle School Building.

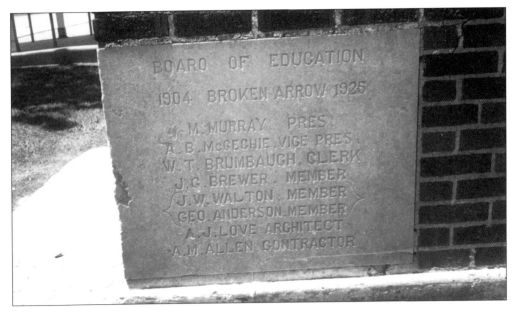

There are two corner stones set in the Middle School Building of some historic interest. *Above:* In the southeast corner is a Board of Education stone listing the members: M. Murray, President; A.B. McGechie, Vice President; W.T. Brumbaugh, Clerk; Members: J.G. Brewer, J.W. Walton, Geo. Anderson; A.J. Love, Architect; and A.M. Allen, Contractor. *Below:* In the northeast corner is a stone laid by the M.W. Grand Lodge, A.F. and A.M. of Oklahoma listing its members: Gilbert B. Bristow, Grand Master; Wm. M. Anderson, Grand Sec. Broken Arrow Lodge No. 243; T.V. Venator, W.M.; E.M. Keener, S.W.; W.T. Swift, J.W.; W.E. Laws, Treas.; and M.C. Williams, Sec. Over the years, the Middle School System was accepted by the Broken Arrow School District and the Middle School became the Central Middle School. A new Centennial Middle School has been built in the north part of Broken Arrow which will replace the Central Middle School.

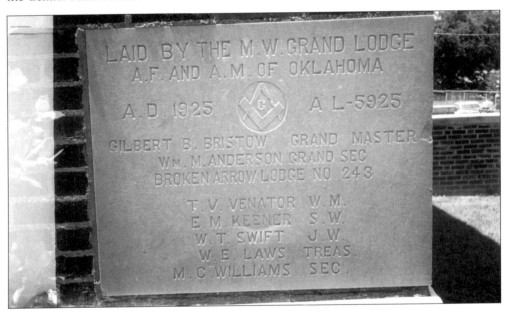

Meanwhile, a new Senior High School complex has been completed and this has become the largest High School in the State of Oklahoma. It is located at 1901 East Albany Street.

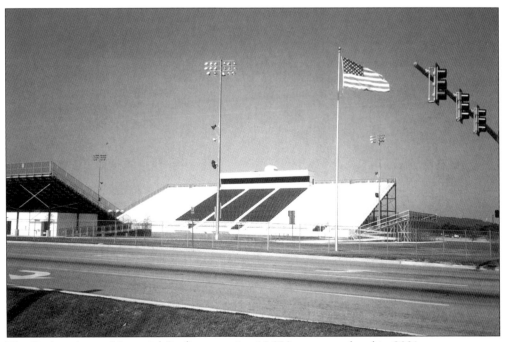

The Broken Arrow Memorial Stadium, seating 10,000, was completed in 2001.

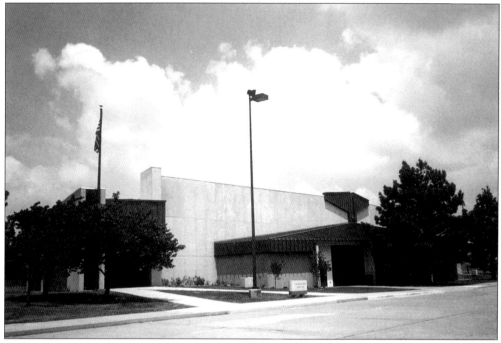

The Tulsa Technology Center is a vocational school where students can learn a skill or technique. It has a campus in Broken Arrow at 111th and Aspen streets.

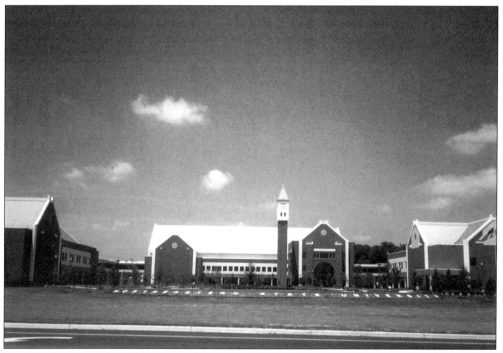

The Northeastern State University Campus at Broken Arrow will be open this fall and will offer 25 undergraduate degrees and eleven graduate degrees. The campus is located at 3100 East New Orleans near the Creek Expressway and East 101st Street, South, interchange.

Six
HOUSES OF WORSHIP

The City of Broken Arrow has over 100 different denominations and religious orders listed in the latest Broken Arrow Chamber of Commerce booklet. In the early days of Broken Arrow, the Methodist, Baptist, Disciples of Christ, Church of Christ, Assembly of God, Presbyterians and Catholic Churches were represented. Some of these early religious groups had more standard versions of worship and service. However, many charismatic church groups are also present, and this may be attributed to the Rhema Bible Learning Center and to the nearby Oral Roberts University.

Two American Indian organizations have made their contributions to the Broken Arrow community. They are the Broken Arrow Indian United Methodist Church and the Haikey Creek United Methodist Church. With the continuing diversity of people in our country, we find some special churches such as the Vietnamese Baptist Church, the Special Chinese Baptist Church at the Arrow Heights Baptist Church, and the Korean Full Gospel Fellowship at the foot of Tiger Hill. The Church of Jesus Christ of the Latter Day Saints (Mormon) has several Wards, and, as these Wards grow in numbers, they may establish their own respective church buildings.

It is of interest that many of these church groups used the Broken Arrow Schools as a starter for their meeting places. One religious group even started at a local funeral home, while another used the Veteran's Building. S.E. Orcutt let religious organizations meet in the upstairs portion of his merchandise dry goods store. Today there are several storefront facilities in Broken Arrow. The Salvation Army holds its meetings at the local Boy's Club in Broken Arrow. It is interesting to look at a vintage image of some of our earliest churches and make comparisons with our most modern edifices.

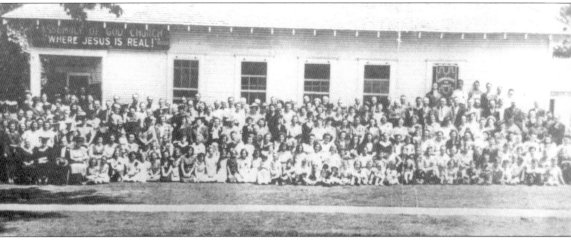

Seen here is the Assembly of God at 305 North Main Street, started on November 7, 1913. Sometimes fire will destroy the sanctuary and a new sanctuary will then be built as in the case of the Assembly of God.

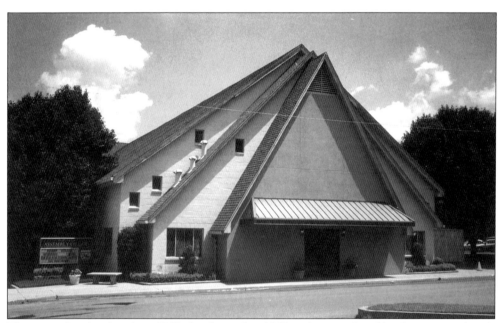

They completed a church in 1950 that burned in 1952 and was replaced by the present church building on June 14, 1953. This congregation had purchased 80 acres of land for expansion at Aspen and 101st Streets. They recently announced that they will acquire the First Baptist Church facilities downtown, which are being vacated for new Baptist facilities at North Albany on the hill.

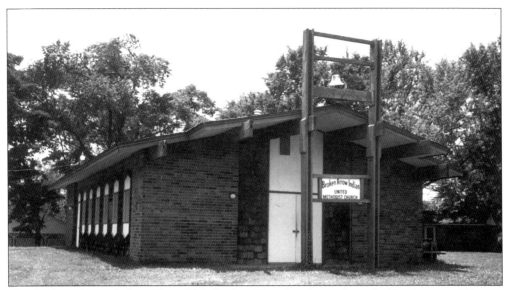

The Broken Arrow Indian United Methodist Church is located one-half mile east of County Road on 141st Street. It was started soon after the end of the Civil War by Reverend James McHenry (1818–1885). The Creek language was used in all services, but since World War II, English is now spoken. There were several small cabins around the church where families would stay or camp during weekend services. Their annual "wild onion" dinners are well known and used for fund raising.

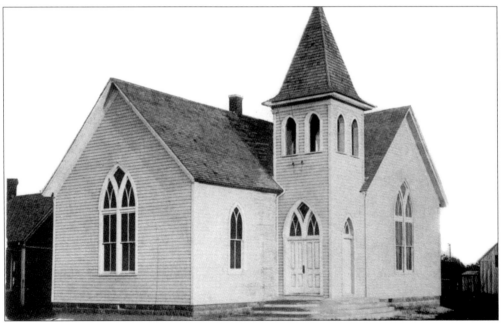

The First Baptist Church is located at 210 East Broadway and at 100 West Albany. It started on February 25, 1904. A group would meet in a railroad car, as the Rev. J.S. Thomas organized a Missionary Baptist Church with nine members. They grew in numbers and acquired land at the corner of First and Broadway. A small white church was dedicated in 1908, which became the First Baptist Church.

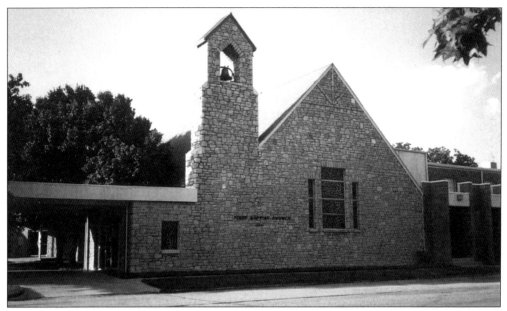

A rock church building was dedicated on May 20, 1951, which was the second sanctuary building. There was still a need for a new sanctuary as more members joined the church.

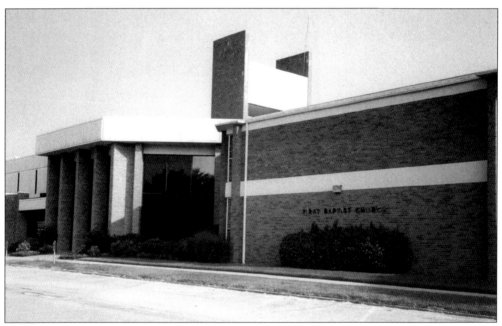

A new auditorium was dedicated on February 10, 1974. With the continued growth of the congregation, a tract of land on top of one of Broken Arrow's mounds was acquired by the First Baptist Church.

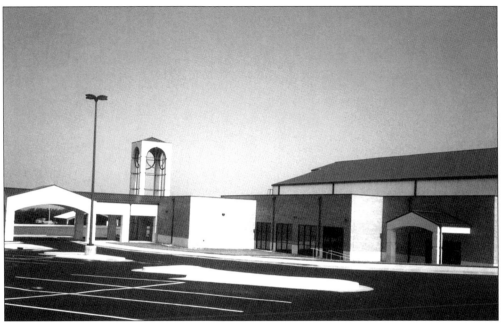

A new church building was completed in 2001 and future plans are to add other facilities.

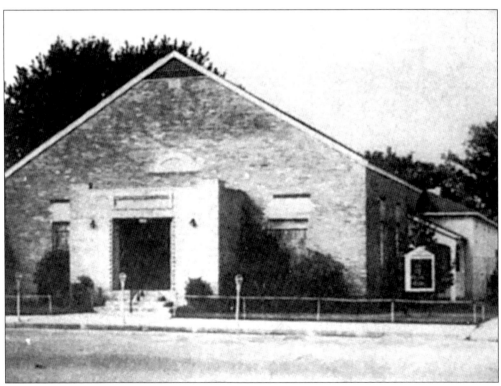

The First Christian Church at 2602 South Elm Place was founded in 1905. The church building was dedicated May 24, 1911. In 1919 a tornado did extensive damage to the church building. It was repaired and an educational wing was added in 1950.

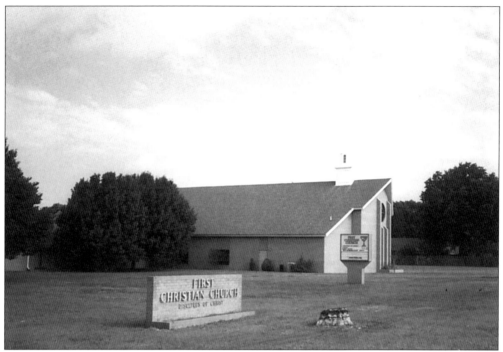

Land was acquired at 2602 South Elm Place and a new church building was dedicated in September 1967. A new sanctuary was added later.

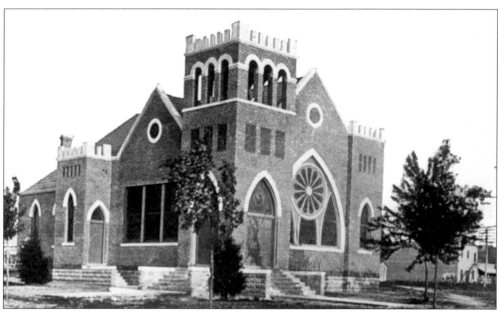

The First Presbyterian Church at 121 West College Street was founded in June of 1905, with 17 charter members. Their first church building was dedicated on December 4, 1910. In 1920 a tornado damaged the church building.

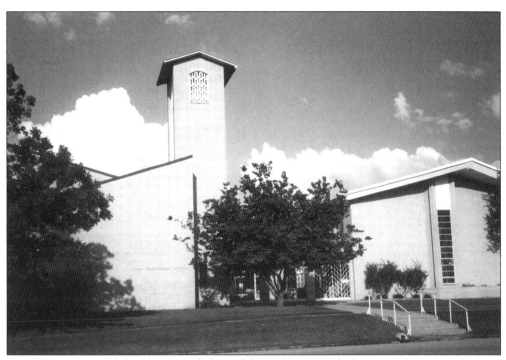

In 1970 a new church building was dedicated. In 1971 a tornado damaged the new structure.

The Haikey Creek United Methodist Church is located at 101st Street and South Memorial Street. The original Haikey Chapel was co-founded by Ben B. and C. Ben Haikey, father and son, in the late 1890s. It was a traditional Brush Arbor on Ben B. Haikey's allotment. The second church was built on land donated by Rose Chisholm's allotment in 1914. Haikey Chapel at one time had nine camp houses around it. The nine Muscogee families who used the houses were Ben and Ella McIntosh, Martha Litka, Louis and Jeanitta Bland, C.B. and Louisa Haikey, Willie and Nancy Alexander, Ben B. and Macy Haikey, Rose Chisholm, Ellis and Shara Haikey, and Edmond and Ella Perryman. Services were in the Creek language, but after World War II, English became dominant.

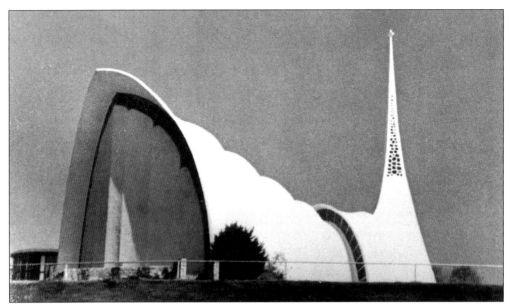

The Immanuel Lutheran Church is located at 216 Luther Drive, and was founded in 1905. German families formed the congregation of this church. Services were in German until World War II. A white frame church was built on property in the 500 block of West College Street. Ten acres were purchased on one of the hills overlooking Broken Arrow in 1956. Construction of the church building designed as a crown for the hill top overlooking Broken Arrow was dedicated in April of 1961.

The Lutherans are presently developing the Immanuel Christian Academy on a tract of land on the west side of Aspen Street, south of Wal-Mart. This will provide school for kindergarten through eighth grade.

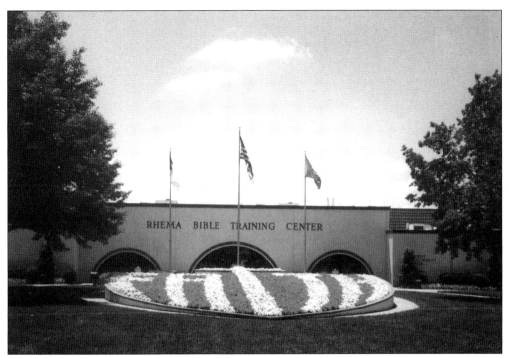

The Rhema Bible Training Center, located at 1025 West Kenosha Street, was founded in 1976. Rhema has a campus consisting of 100 acres.

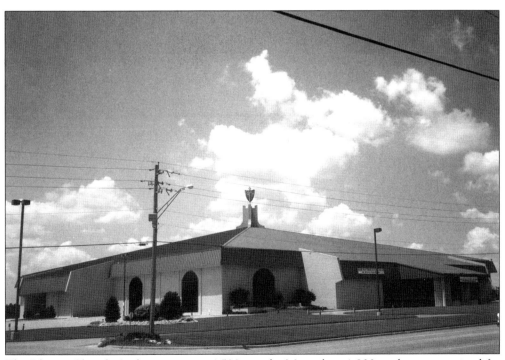

The Rhema Church Auditorium seats 4,500 people. More than 1,800 students are trained for the ministry each year.

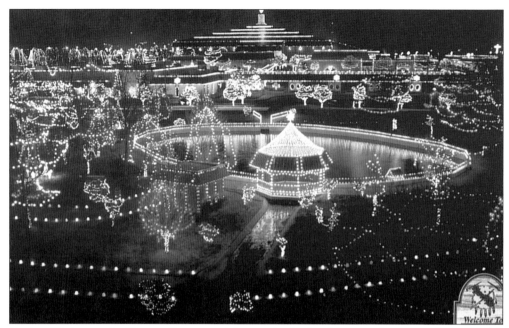

During Christmas the Rhema Campus celebrates the birth of Jesus with a magnificent display of millions of lights.

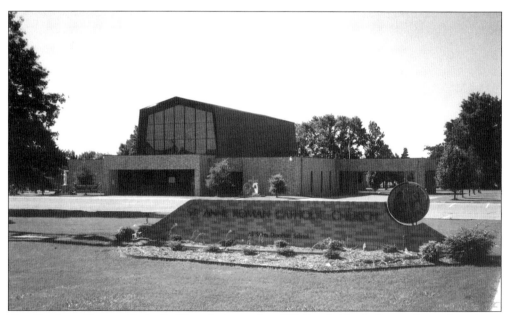

The St. Anne Roman Catholic Church, located at 301 South Ninth Street (Lynn Lane) was founded in 1903. In 1903 the Jacob Middleton family's home was used by three Catholic families for religious purposes. In 1936 a church building was moved from Jenks to the present site on South Ninth Street. In 1948 St. Anne's Parish was entrusted to the Capuchin Order and the role of pastor was assumed. In 1954 the All Saint's School was established. Today a modern sanctuary has been added as shown in the current photograph.

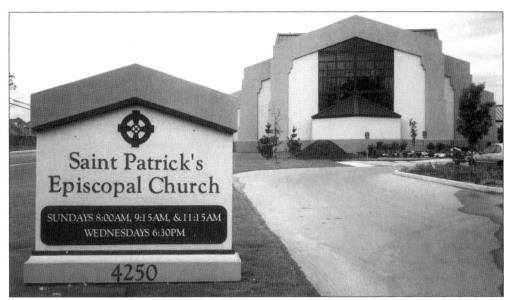

St. Patrick's Episcopal Church, located at 4250 81st Street was founded in 1961. It was organized after a telephone survey indicated enough interest to start a local mission. The first service was held in Kennard's Funeral Home on Sunday, March 26, 1961. Some acreage was purchased in October of 1962, and a chapel was built on North 9th Street below Tiger Hill. Other additions to the chapel included Parish Hall and an educational building. In 1998 some acreage in the west part of Broken Arrow was purchased and a new sanctuary was built with classrooms. The old sanctuary and land was sold to the Korean Full Gospel Fellowship.

Arrow Heights Baptist Church, located at 3201 South Elm Place was founded August 31, 1955. It began by meeting at the Veteran's Building. The first services were held September 4, 1955, with 100 charter members. They acquired land at 1800 South Main and had four major building projects completed by 1964. The church then purchased five acres on South Elm Place and added another 6.9 acres and began building again. The first facility was a Christian Family Center. On July 19, 1983, the congregation participated in a "walk-over" from Main Street to South Elm Place. Ground was broken in 1983 for the Preschool and Children's Building, which was dedicated on June 2, 1985. A sanctuary was completed and an average of 600 to 700 people attend each worship service.

The First United Methodist Church, located at 112 East College Street, was founded October 8, 1903. Their first project was to build a church on land donated by the Arkansas Valley Townsite Company. The Methodist church was first used as a school in Broken Arrow until a new public school building was completed across the street. Rev. R.L. Cole was sent by the Methodist Conference to be the first minister. Until a house was available in Broken Arrow, Rev. Cole, with his wife and two children, lived in Catoosa. Rev. Cole then pedaled a bicycle 12 miles, twice monthly, to preach in Broken Arrow. In October of 1904, Rev. C.B. Larabee became the new pastor. An addition to the church was built along with a steeple with bell. The bell was donated by a St. Louis firm and second-hand pews were obtained.

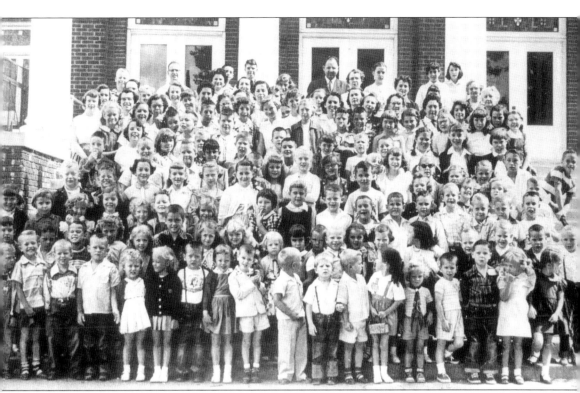

A Sunday School Class photograph taken on the front steps of the 1920 sanctuary, *c.* 1960.

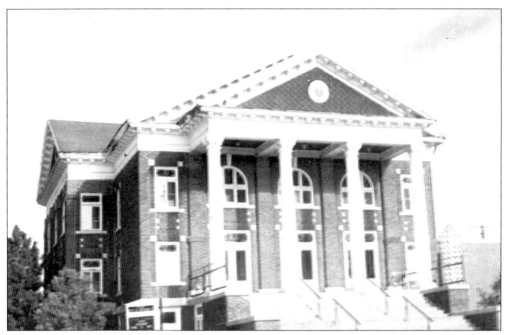

By 1920 a new and larger sanctuary was needed. It was built of bricks with white metal columns at the entrance. This new sanctuary served the congregation for over 50 years before being destroyed by fire on January 15, 1982. Meanwhile, the merger of two Methodist churches in Broken Arrow took place on July 5, 1926.

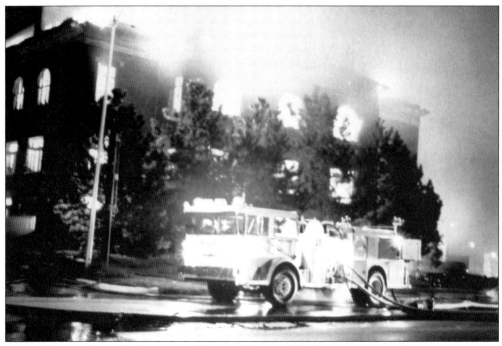

Pictured here is the 1920 Sanctuary that was destroyed by fire on January 15, 1982.

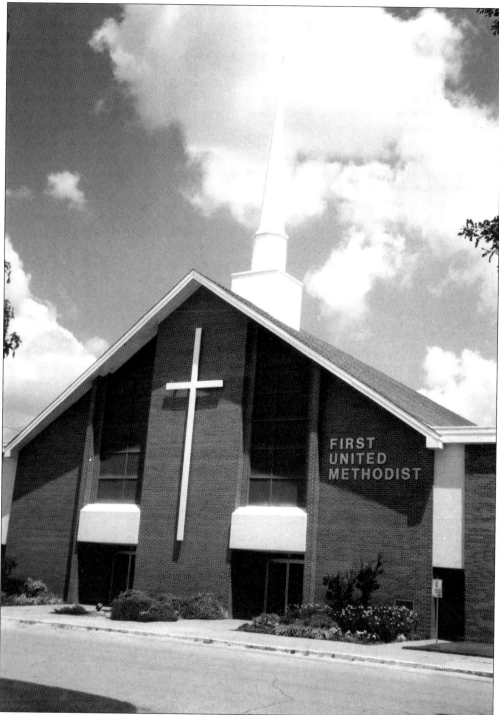

The Children's Building was constructed and dedicated on April 16, 1961. A new sanctuary was built in 1976 with seating capacity of 650. Additional Sunday School rooms were available in this building, along with the church offices, library, choir room, reception rooms, and a small kitchen.

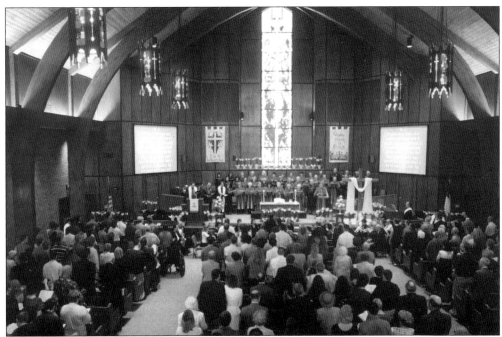

Seen here are FUMC Easter Services, 2002.

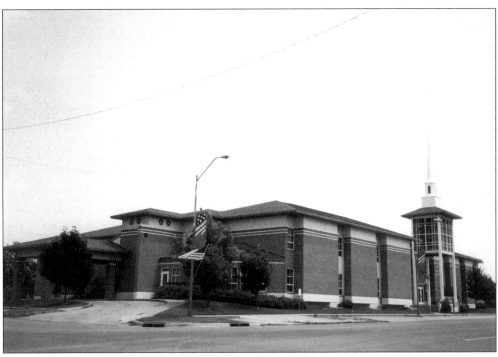

A new Activity Building was dedicated on March 7, 1993. It includes Fellowship Hall, Sunday School rooms, a nursery, full kitchen, a stage, and activity area. The 90th Anniversary of the First United Methodist Church was commemorated during October of 1993. A new parsonage was purchased by the Church for our senior pastor on April 20, 2001.

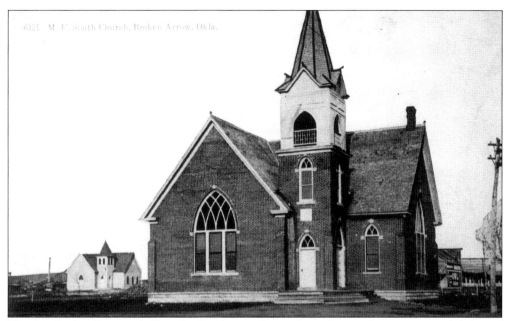

The Methodist Episcopal Church, South, was located on the northeast corner of Ash and Broadway (where the Valor Building now stands). It was founded September 4, 1904, with 48 charter members. Their first pastor was Rev. Joe B. Hedgepeth. The dedication of the M.E. Church, South, took place on September 24, 1905. The two Methodist churches decided to merge because of economic reasons. This took place on July 15, 1926. The M.E. Church, South, building was sold and this congregation met in the larger sanctuary of the 1920 church building.

The Church of Christ was originally located on northeastern corner of Ash and Broadway streets, and was founded in 1915. At first it met at various family homes until they rented the court room in City Hall. In 1927 the church bought a building from the Methodist Episcopal Church, South. After a while, church members decided to tear down the original building and to build a new one. The members did all the work. The current site of the Church of Christ was purchased in the 1960s and church members met for the first time in the new church in 1964. The main auditorium was added on in the early 1980s in addition to a community outreach center and 10 to 12 more classrooms. A church history was published in 1997 entitled *75th Anniversary: 1922–1997: Hearts Turning Home*. The church is presently located at 505 East Kenosha.

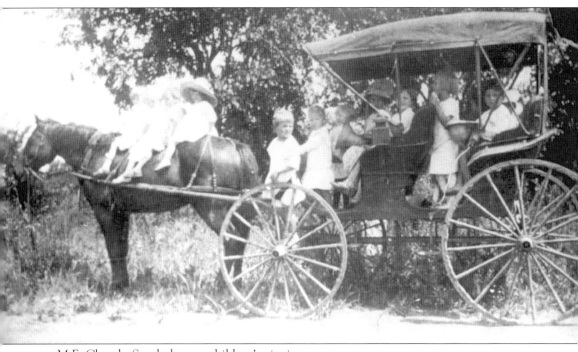

M.E. Church, South, hosts a children's picnic.

Seven
PARADE OF HOMES

There are a variety of homes in Broken Arrow. Most of the early homes were of wooden structure varying in size and shape by the individual's taste in architecture and what he could afford. Some homes used brick for siding and appearance. Since the town of Broken Arrow was a new development on prairie land, the planting of trees, shrubbery and flowers added much to its setting.

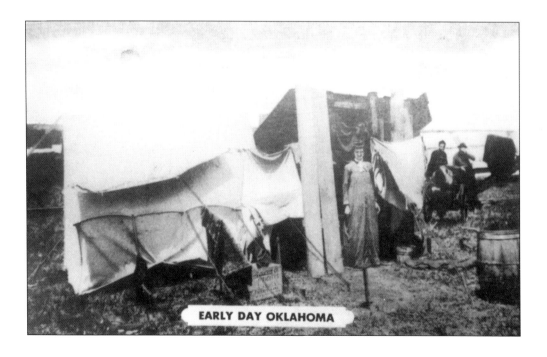

EARLY DAY OKLAHOMA

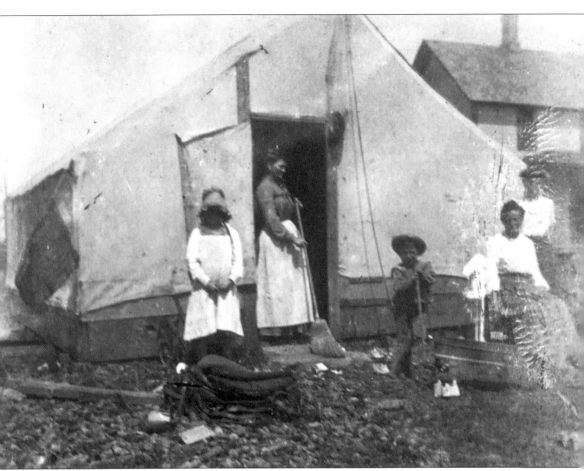

Tents were used by the early settlers until a more substantial type of housing could be obtained. Many store owners had their families living in the back of the store or upstairs until a new home could be purchased. All lumber and building supplies had to be shipped to Broken Arrow from dealers located elsewhere. Merchants in St. Louis and Kansas City provided much of the needs of the local people.

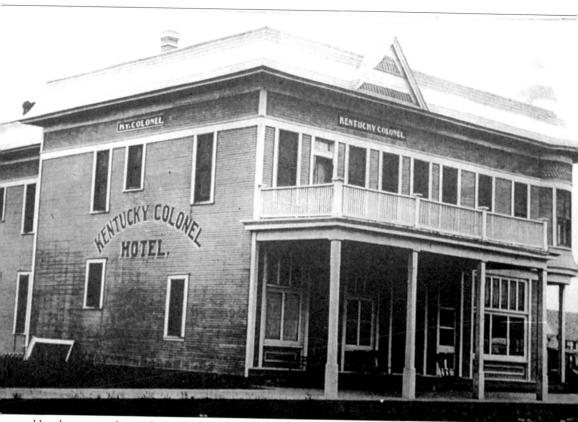

Hotels were in demand. Fitzsimmons Hurd describes a hotel in Broken Arrow where he stayed. He slept on the floor with a blanket. There were also 22 men sleeping on the floor of this new hotel. Later some hotels in Broken Arrow became well known because of the food which they served. Better known hotels in Broken Arrow were the Kentucky Colonel, Cottage Hotel, and Simmons Hotel.

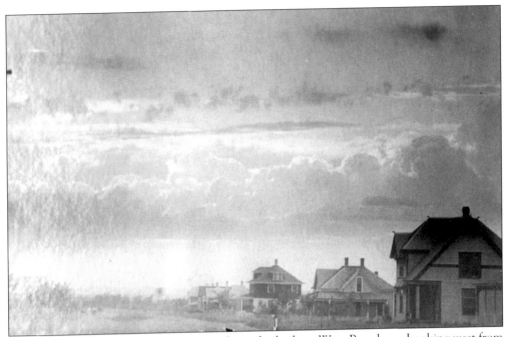

This image shows some of the new houses being built along West Broadway. Looking west from Main Street and along West Broadway there are three houses completed. The first house on the right is the home of John Y. Staats. The second house on the right is the Nathaniel L. Sanders home. The Fitzsimmons Hurd house is third from the right.

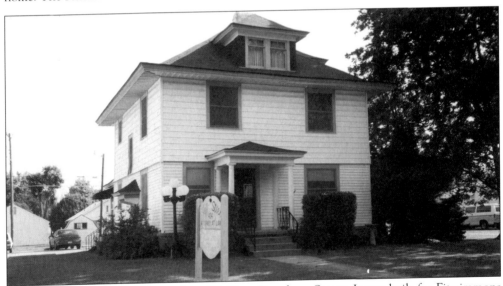

The Hurd-Steen Home is located at 404 West Broadway Street. It was built for Fitzsimmons Hurd in 1904. F.S. Hurd was the cashier at the Traders and Planters Bank in Broken Arrow. Later the bank name was changed to the First National Bank of Broken Arrow. Jeff and Debra Steen purchased the home from the Hurd family in July, 1985. The Steens have restored the downstairs and added a bathroom, garage, and service area. Central heat and air-conditioning have also been added. Many of the furnishings are antiques from the owner's private collection. This Colonial Revival style home is one of the historic landmarks in Broken Arrow.

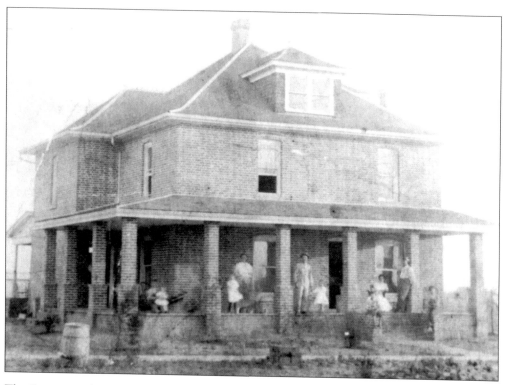

The Superintendent's Home is located on southwest corner of East College Avenue and North Fifth Street. This two-story brick house was built in 1910 for the superintendent of the Haskell State School of Agriculture. J.H. Esslinger and family were the first to live in this home. The brick used in this home was from the William R. Sullivan brick yard in Broken Arrow. J.H. Esslinger was married to one of Sullivan's daughters. The original campus is across the street or due east of the Superintendent's Home. Shown above is an image of the home in 1910 and below this photograph is a 2002 photo of this same house.

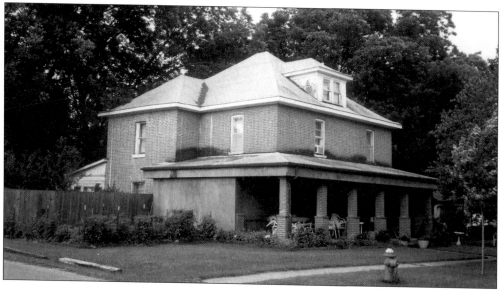

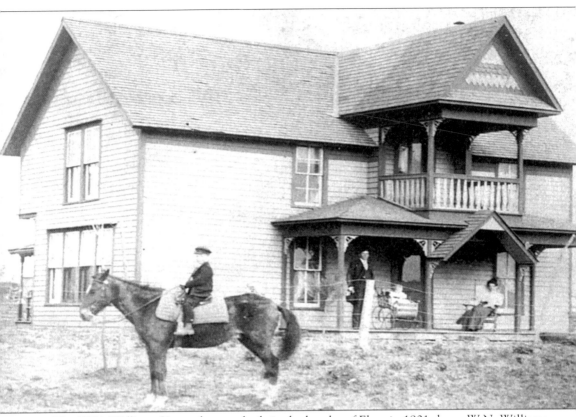

The W.N. Williams Home that was built in the hamlet of Elam in 1901 shows W.N. Williams standing on his front porch. The baby is the daughter, Anna, and Mrs. W.N. Williams (Ida Knight) is shown sitting to the right of Anna. The Williams' son, Vernon, is sitting on a horse. In 1903, this house was put on skids and a steam tractor pulled it down the road for 5 miles onto a lot in the new town of Broken Arrow. The house was demolished several years ago.

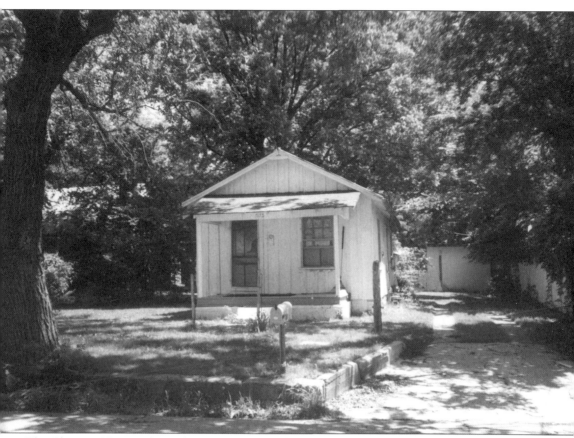

This Shotgun House is located at 523 North Birch. Broken Arrow has many old homes dating from the original settlement in 1902. This house is known as a "shotgun house" because it has only two rooms. A person holding a shotgun at the front door could shoot through such a house with no problem. It was probably built in 1910.

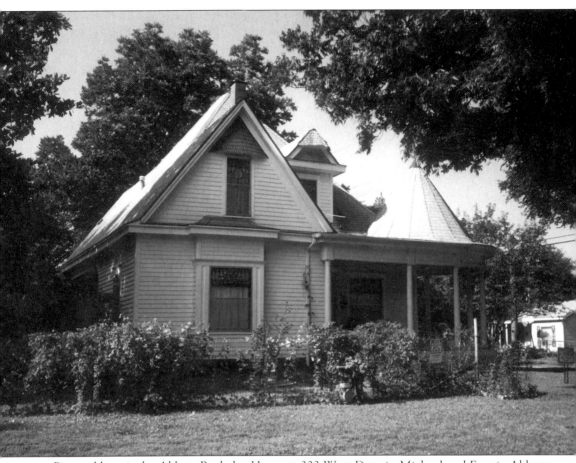

Pictured here is the Abbott-Rutledge Home at 323 West Detroit. Michael and Fannie Abbott came from Illinois. He was in business with Blair and Abbott Hardware Furniture and Undertaker Parlor in Broken Arrow. This home was built in April of 1903. The Abbotts were Roman Catholics. Broken Arrow had no Roman Catholic Church in the early days. A priest from Tulsa would conduct mass in the Abbott home for all Catholic families in the area. The Abbott Home is an example of the Queen Anne style, with asymmetrical composition of turreted roof, tall chimney, encircling veranda, and multi-gabled roof. This home has five rooms downstairs, a bathroom and three rooms upstairs. This home was purchased in 1975 by the Kerm Rutledge family. The present owners have made extensive renovations since that time. The home has been modernized with new wiring, new plumbing, heating and air-conditioning.

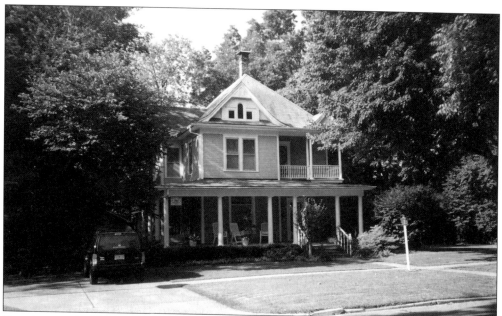

Seen here is the Williams-Burdette Home at 307 West Commercial Street in Broken Arrow. The lot was purchased by the Laws family around 1906 and the house was built in 1910. The architectural style is of no specific period, but is sort of a modified two-story farm house with Tuscan columns across the front and a slight Victorian appeal. In 1926 the house was purchased by William "Newt" Williams. The Williams lived in the house until 1984 when it was purchased by Jim and Mindy Burdette. Few changes have been made in the original floor plan.

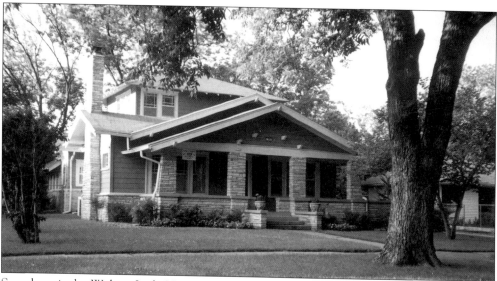

Seen here is the Walton-Ingle Home at 308 East Commercial Street. This home was built in 1919 by Mr. Williams, a teacher of shop at school, and since 1961 has been owned by the Ingle family. It has seven original rooms, two bathrooms, and a one room basement with kitchen entry. The upstairs contains one large bedroom and bath. Striking features of the house are a large number of windows and large front and side porches. The interior rooms have oak floors and redwood siding covers the exterior. This home is a reflection of early life in Broken Arrow.

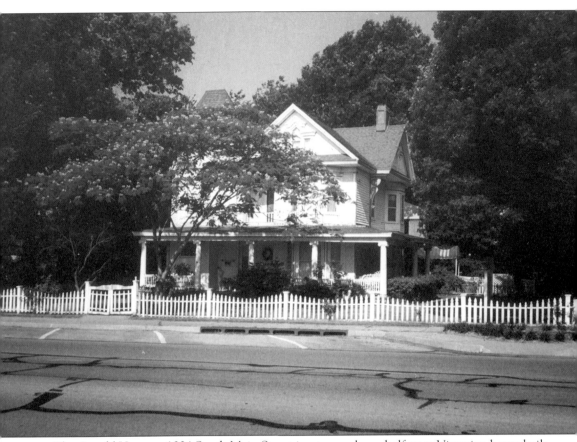

The Arnold Home at 1004 South Main Street is a two and one-half story Victorian house built by Ed Arnold in 1904. Its eclectic style includes neo-classical columns rimming the veranda, medieval turret, palladian windows, and intricate ornamentation around the windows, eaves and porches. It had central heat and air-conditioning added in 1977.

Seen here is the Wilson-Laws Home located at 724 North Main Street. "Diamond Joe" Wilson came from Tennessee to Oklahoma in 1905. He was a Tulsa architect, builder, lumberman and extensive owner of residential and business property. Wilson built this home in 1924 and Joe Laws inherited this property at the time of his uncle's death in 1929. This brick home has a Spanish tile roof and 9-inch thick walls. There are six rooms, a full bath, two half baths, and a full basement. Major features are the overhanging portico at the entrance and a large screened porch with its floor covered with Italian ceramic tile.

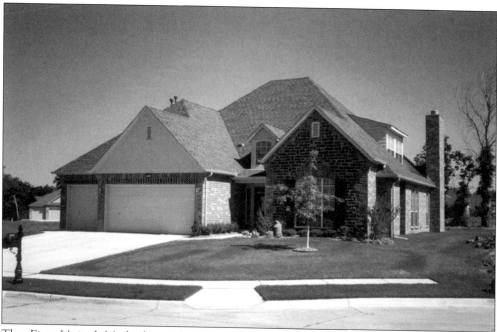

The First United Methodist Church Pastor's home at 1904 West Charleston Street in Waterford Park is a typical type of housing being built in 2002 in Broken Arrow. It consists of a three-car garage, four bedrooms, a large living room, kitchen, family room, and three bathrooms. It has central heat and air-conditioning. The total frontage is 3,000 square feet, and the original cost was $230,000.00.

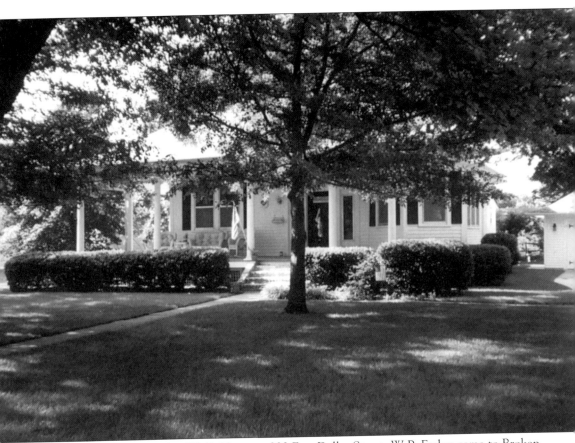

Pictured here is the Fraker-Wells Home at 233 East Dallas Street. W.P. Fraker came to Broken Arrow in 1903. He was married to Jeanette Wells and was a banker of the First State Bank. Fraker purchased a 40-acre farm whose outer boundaries were Dallas Street to 81st Street and First to Fourth Streets. He raised Shorthorn cattle, alfalfa, apples, and peaches on the farm. Fraker had a one-story house built on his farm in 1911 by Lemont Francisco, a local carpenter. The house was constructed of pine, oak and walnut trim in the interior. The house had redwood siding and consisted of five rooms and a wraparound screened porch. Special features of the house include 10-foot ceilings, a corner brick fireplace with a walnut panel in the living room, a small piano room, and a built-in china cabinet in the dining room made of walnut. Fraker's nephew, Fred Wells, who was married to Helen Gaddy, purchased the house and farm in 1942. Ed Wells, Fred's father, was in the grain elevator business in early Broken Arrow. In 1961 Fred and Helen Wells decided to subdivide their 40-acre farm and to retain a one-quarter acre lot on which the house stands. The subdivision became the Barry Dayton Addition to the city of Broken Arrow.

Eight

SPECIAL EVENTS

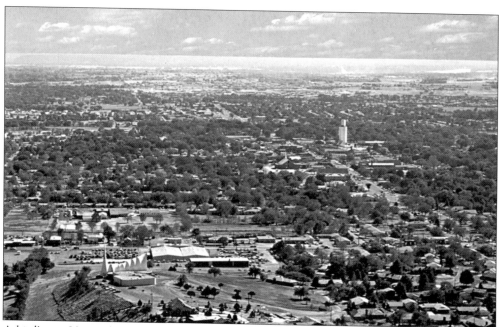

A bird's-eye View of Broken Arrow, Oklahoma shows, in the lower left corner, the Immanuel Lutheran Church. One outstanding landmark is the 150-foot concrete grain elevator shown in the middle right portion of this view.

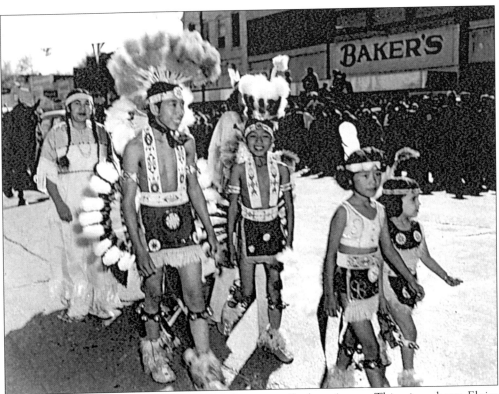

Rooster Day Parade has become an annual event in Broken Arrow. This view shows Eloise Boudinot, a Muscogee (Creek) Indian, and several American-Indian children from the Marshall family in their Indian outfits marching down Main Street.

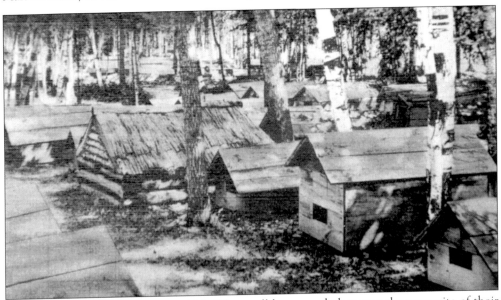

In the past, American Indians would build a small house or shelter over the grave site of their ancestors or a loved one. These burial grounds would provide protection from the elements for the departed one. Today most American Indians are buried in modern, public cemeteries.

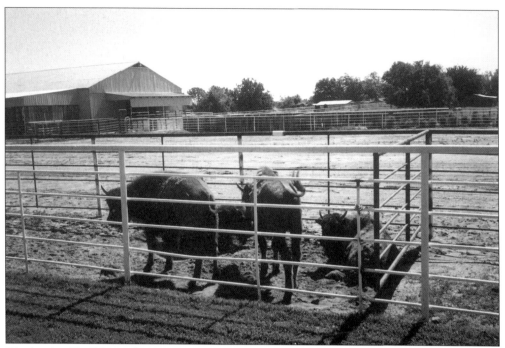

The herds of buffalo are long gone from the plains. These young buffaloes are being raised by a rancher in the City of Broken Arrow.

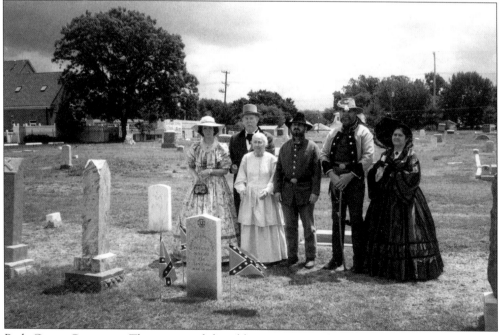

Park Grove Cemetery: This is one of the oldest cemeteries (est. 1904) in Broken Arrow. A previously unmarked grave of a Confederate veteran, 2nd Lt. Edmond Ellis Dodson (1835-1920), is being honored and acknowledged by several reenactors in vintage clothes of this period.

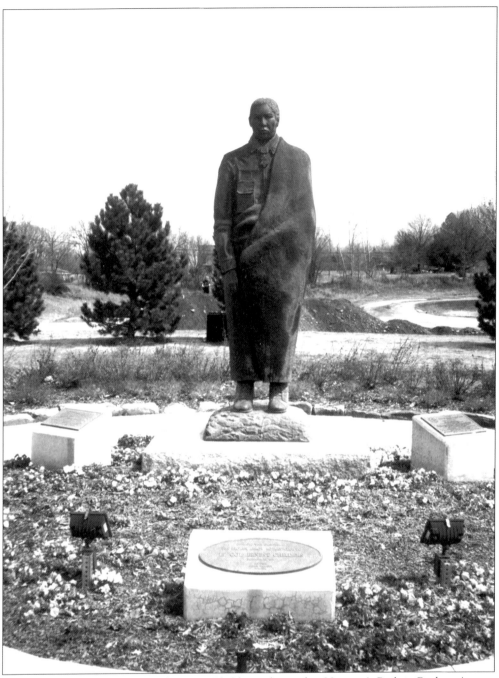

A bronze 9-foot statue of Lt. Col. Ernest Childers is located in Veteran's Park in Broken Arrow. Lieutenant Childers was assigned to Company C, 180th Infantry Regiment, 45th Division, U.S. Army, during World War II. He was awarded the Congressional Medal of Honor for his military action in Sicily. The statue of Childers was done by Allan Houser, an American-Indian artist.

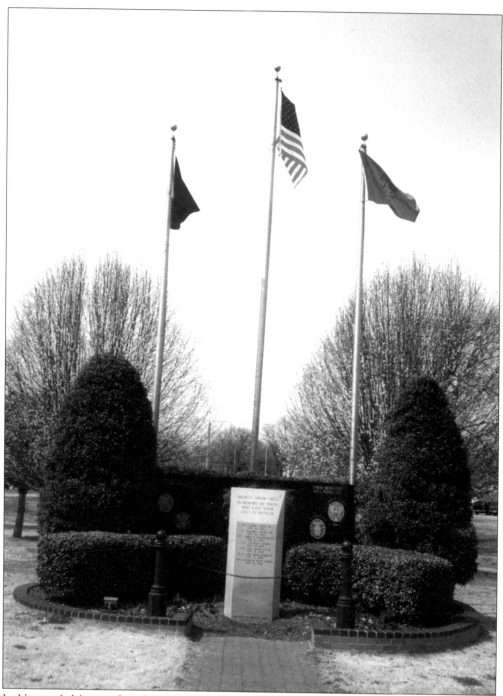

In Veteran's Memorial in Central Park there is a memorial to the memory of those who gave their lives in Vietnam. Seven names are listed along with their rank and date of death. Three flags include the American flag, the Oklahoma flag, and the M.I.A. (Missing in Action) flag.

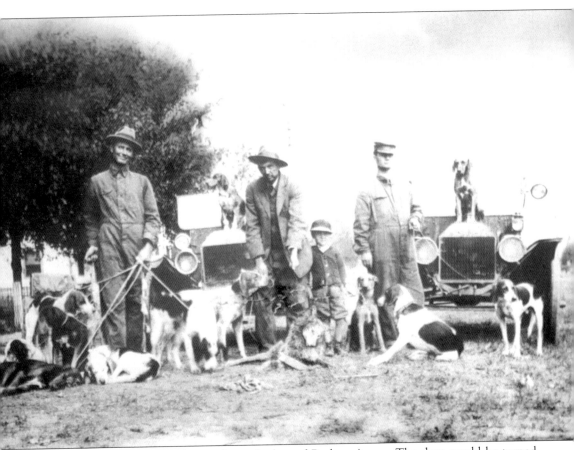

Wolf hunts were popular during the early days of Broken Arrow. The dogs would be turned loose and the hunting party could watch the dogs chase either wolves or coyotes from the high mounds in Broken Arrow. On the left is a 1912 Ford Model T and on the right is a 1913 Ford Model T.

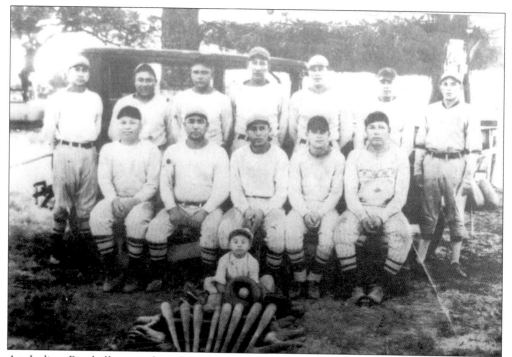

An Indian Baseball team, from left to right (front row) Almon Sawyer, Ellis Haikey, Legus Drew, Jack Bennett, and Jessie Haikey; (back row) Amos Beaver, Michael Boudinot, Grover Alexander, Lewis Perryman, Herbert Haikey, Clarence Haikey and J.W. Tiger.

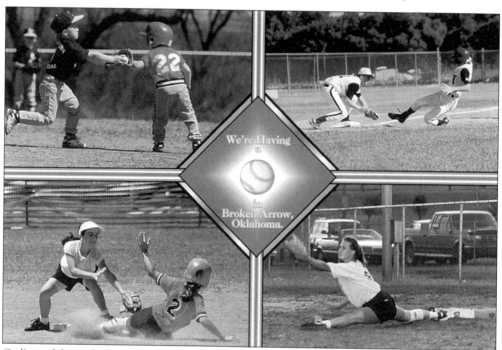

Girl's and boy's ball Teams "have a ball' in Broken Arrow, which is home to many state, national, and international tournaments.

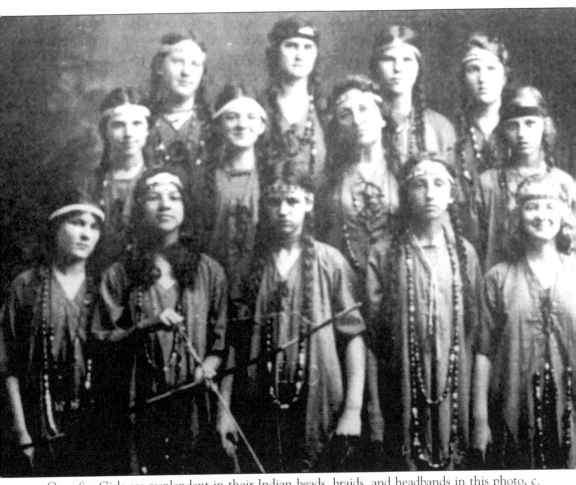

Campfire Girls are resplendent in their Indian beads, braids, and headbands in this photo, *c.* 1918.

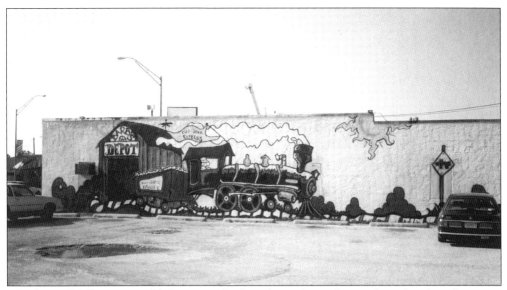

Mural on a Wall on an establishment in Broken Arrow located near the railroad tracks.

God Bless America—A sign of local patriotism, cups on a cyclone fence.

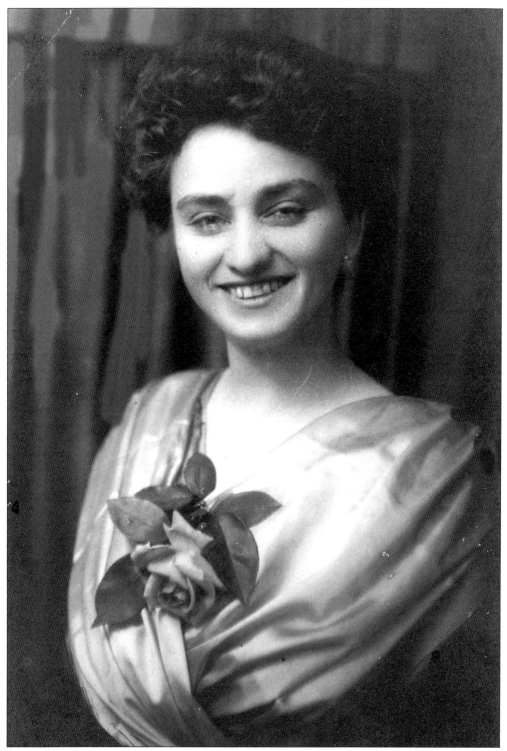

Phenie Lou (Gillett) Ownby (1887–1954) was the first and only woman mayor of Broken Arrow.

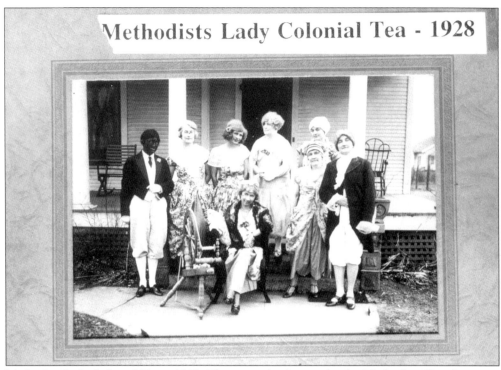

Methodists Lady Colonial Tea - 1928

Methodist Lady Colonial Tea—1928. This was a fund raiser for the Methodist Church.

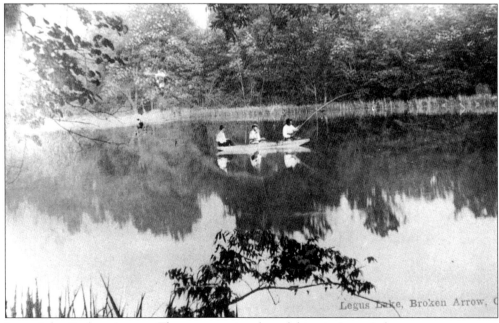

Legus Lake, Broken Arrow, C

Legus Lake, Broken Arrow—Three persons in a boat fishing in Legus Lake.

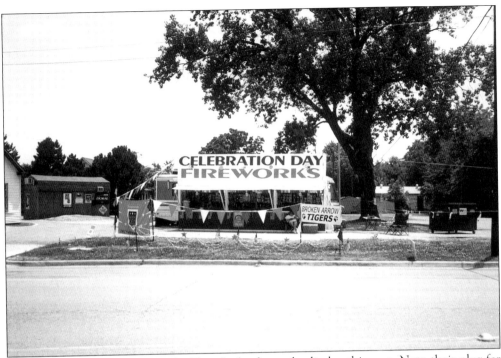

The Broken Arrow Indian Smoke Shop had a fireworks display this year. Note their plug for the Broken Arrow Tigers.

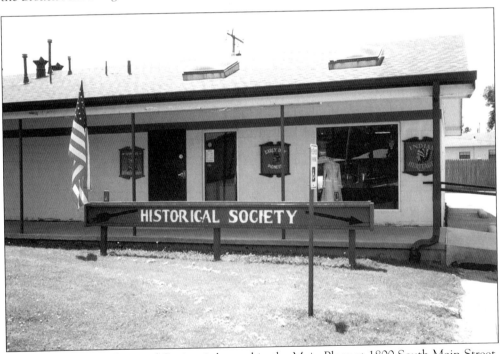

The Broken Arrow Historical Society is located in the Main Place at 1800 South Main Street. Although only established in 1976, it is collecting items relating to Broken Arrow and its history.

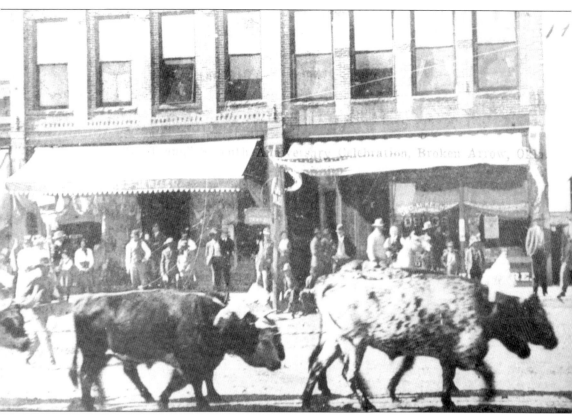

Broken Arrow Seventh Anniversary Parade down Main Street, *c.* 1910. This team of oxen was a favorite item of the crowds.

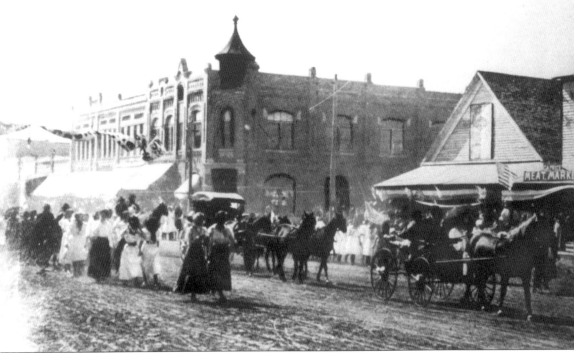

Another Seventh Anniversary Parade down Main Street, *c.* 1910. Note the classic building with a cupola where First State Bank was located. There is an American flag in front of the butcher shop to your right in this image, *c.* 1910.

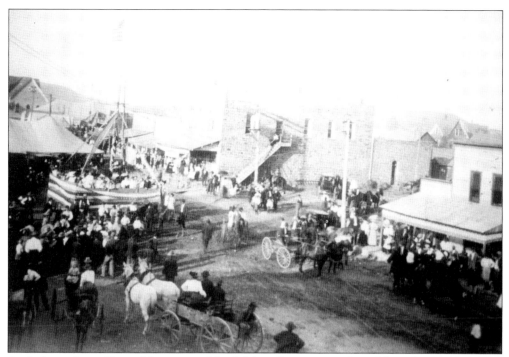

An Independence Day celebration on North Main Street is seen here. Note the American flag on tall flag pole at the intersection of Broadway with North Main Street. To the far left is the M.E. Methodist Church. The two-story stone building on the northeast corner of Broadway and Main streets was called the "Farmers Wagon General Store" in this image. It was later a laundry, Pontiac dealership, and an automobile parts store until it burned in the 1950s. Today a single-story antique shop is on this site. In the background is the Broken Arrow Mound, now known as Tiger Hill.

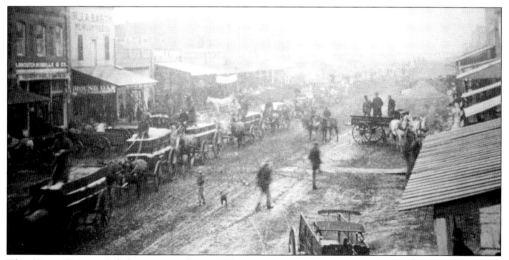

The King Cotton Jubilee is seen here. When cotton was a major crop in the local area, an annual Cotton Jubilee was held each October. Here you can see the line of cotton wagons moving down Main Street in Broken Arrow. The cotton gins offered a bonus for cotton brought in on this day, c. 1915.

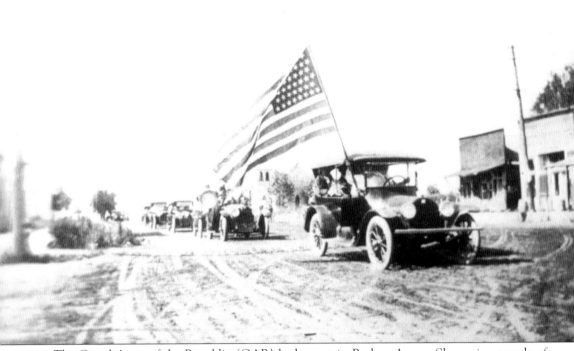

The Grand Army of the Republic (GAR) had a past in Broken Arrow. Shown is a parade of vintage vehicles with GAR members driving down Main Street in Broken Arrow. Note the M.E. Methodist Church in the background under the American flag.

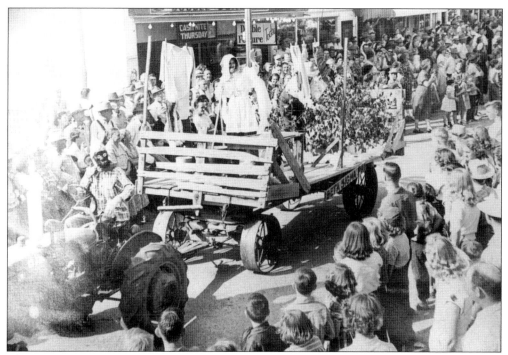

The Cotton Jubilee Parade seen moving down Main Street in Broken Arrow. The tractor pulling a trailer representing a cotton picking crew. The marquee of the theater indicates a double-feature event.

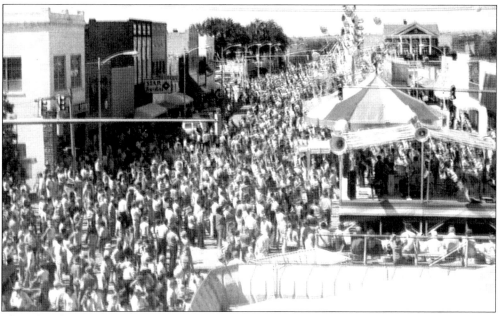

The Chamber of Commerce started Rooster Day in 1931 and it has continued annually and grown in size and activities each year. A special day was set aside for farmers to bring their excess roosters to town and sell. As years passed a carnival and other activities were added. They even had Bob Wills and his Texas Playboys participate one year.

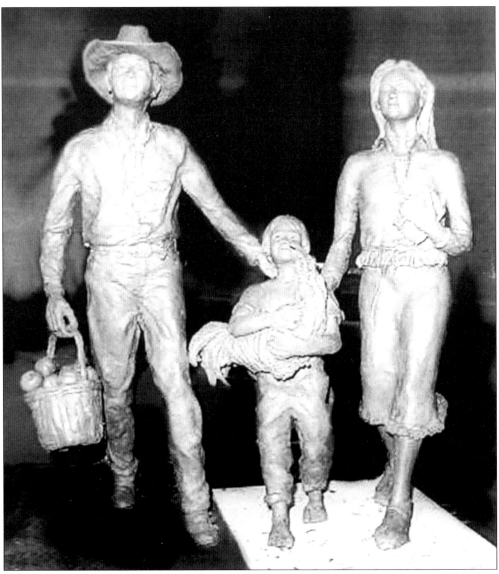

Broken Arrow Centennial Celebration—This year the 100th birthday of the City of Broken Arrow will be recognized. A Centennial Park in the downtown area will feature a statue representing a farmer with his basket of apples, a young boy holding a rooster, and an American-Indian woman representing our pioneer background. There will be other events occurring throughout 2002-2003. This $98,000 bronze statue will be 9 feet tall and was sculpted by David Nunelly. It will be dedicated on October 19, 2002, in Broken Arrow's Centennial Park.

SELECTED BIBLIOGRAPHY

Apsley, Marmie, Jack McGinty, and Donald A. Wise. *1910 Federal Census Schedules for Town of Broken Arrow and Boles, Fry, Lynn Lane and Willow Springs Townships, Tulsa County, Oklahoma*. Broken Arrow: Broken Arrow Genealogical Society, 1993, 146 p.

Baird, W. David and Danney Goble. *The Story of Oklahoma*. Norman: University of Oklahoma Press, 1994, 511 p.

Broken Arrow Democrat (Newspaper) Sept. 8, 1903–Mar. 10, 1911.

Broken Arrow Genealogical Society. *Oklahoma Green Country Cemeteries*. vol 1, 1984, 179 p. vol. 2, 1989, 226 p.

Broken Arrow Ledger (Newspaper) June 16, 1904–Present.

"Broken Arrow, Oklahoma: From Past to the Future," *Broken Arrow Ledger* (Thursday, Feb. 20, 1997): 12 p.

Debo, Angie. *Tulsa: From Creek to Town to Oil Capital*. Norman: University of Oklahoma Press, 1943, 123 p.

———. *The Road to Disappearance*. Norman: University of Oklahoma Press, 1941, 400 p.

McReynolds, Edwin C. *Oklahoma: A History of the Sooner State*. Norman: University of Oklahoma Press, 1954, 474 p.

Rhodes, W. Cecil. *Establishment and Development of Broken Arrow, Oklahoma*. Tulsa: Moongate Enterprises, 1976, 81 p.

Tulsa Daily World (Newspaper) Nov. 1, 1906—Present.

Tulsa Democrat (Newspaper) Sept. 27, 1904–Dec. 5, 1919.

Tulsa Morning News (Newspaper) Nov. 3, 1916—June 31, 1919.

Tulsa Tribune (Newspaper) Dec. 6, 1919–Sept. 30, 1992.

Wise, Donald A. *Broken Arrow Vignettes: Brief Local Histories*. Broken Arrow: Re Tvkv'cke Press, 1989, 61 p.

———. Editor. *The Broken Arrow Chronicles*. Broken Arrow: Broken Arrow Historical Society, 1987, 69 p.

———. *First Census (1904) of Broken Arrow*. Broken Arrow: Re Tvkv'cke Press, 1994, 89 p.

———. *Myriads of the Past*. Broken Arrow: Re Tvkv'cke Press, 1987, 93 p.

———. "Origin of the Place Name 'Broken Arrow.' *The Chronicles of Oklahoma*, vol. LXIX, no. 1 (Spring, 1991): 92–97.

———. *Tracking Through Broken Arrow, Oklahoma*. Re Tvkv'cke Press, 1987, 69 p.

Church Histories

Broken Arrow Assembly of God 75th Anniversary: 1917–1992. Broken Arrow: 1992, 44 p.

Church of Christ: A History 1922–1997. Broken Arrow: 1997, 262 p.

First United Presbyterian Church. *Seventy-Fifth Anniversary: 1905–1980*. Broken Arrow: 1980, 21 p.

Holder, Carolyn . *Milestones in the Ministry: 1904-1979. A 75th Year History of the First Baptist Church, Broken Arrow, Oklahoma*. Broken Arrow: The Printing Press, 1979, 56 p.

Hurd, Fitzsimmons. *Life of F.S. Hurd*. Broken Arrow: Manuscript by F.S. Hurd. 1912, 40 p.

Immanuel Lutheran Church. *The First 75 Years of God's Blessings*. Broken Arrow: 1987, 27 p.

St. Anne's Catholic Church. *Parish on the Move: Silver Jubilee History*. 1973, 27 p.

Wise, Donald A. *History of Scout Troop 104*. Broken Arrow: Re Tvkv'cke Press, 1991, 34 p.

———. Editor. *Journeys into Faith Through Ninety Years: 1903–1993*. Broken Arrow: First United Methodist Church, 1993, 40 p.